PEGASUS
Library

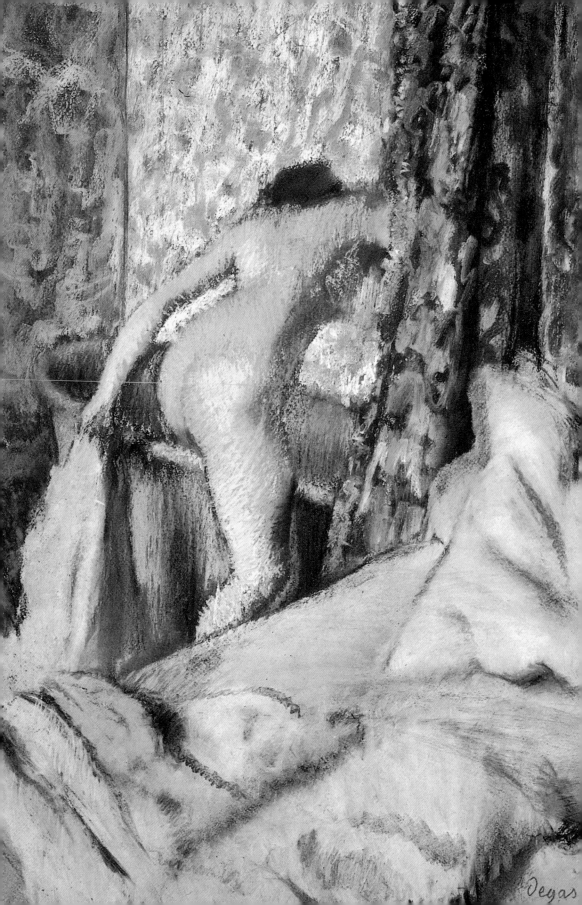

Lillian Schacherl

Edgar Degas

Dancers and Nudes

Prestel

Munich · New York

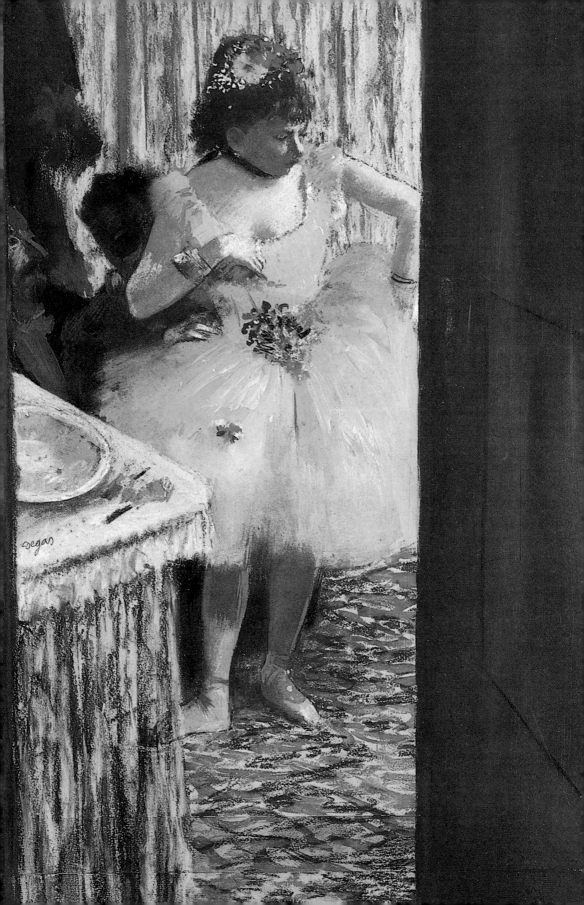

Contents

Ballet Dancer in Her Dressing Room,
1878–79

Male Fantasies and Female Vengeance

When the sixth Impressionist exhibition opened in Paris in 1881, the male-dominated art world was plunged into frenzied outrage by the sight of a teenage girl. Or, to be more precise, by the sight of a colored wax sculpture of a teenage girl, captured in a characteristic dancer's pose. The figure was decked out with items of real costume. This would have been sensational enough in itself, but what really upset the viewers was the dancer's facial expression. In the words of one critic: "The pug-nosed, vicious face of this scarcely pubescent girl, a blossoming street urchin, remains unforgettable." Others described the figure as "a precocious flower of depravity" or as a "juvenile monster," with "the shamelessness of an animal" and therefore "fit to be shown only in a museum of zoology or anthropology."[1] The provokingly haughty teenager, with her high cheekbones and firm-fleshed body, had evidently become a magnet for the fantasies of men whose lurid turn of phrase indicates a keen interest in the subject matter that they condemned with such vehemence. Thus Edgar Degas' *Little Dancer of Fourteen Years* (illus. opposite) aroused a controversy that still makes the work a significant document of its time.

The revenge of the other side followed a century later, when women art historians working from a feminist perspective began to reexamine Degas' representations of the female body. Much attention, for example, has been devoted to the plump nude figure in the pastel *The Morning Bath* (illus. p. 96). This, so the feminist argument runs, is a demeaning image of woman as pure sensual animal, designed to appeal to a patriarchal society whose attitude to the body wavered between fascination and disgust—and created by an artist whose own sexuality was severely disturbed.[2] However, the feminist position, summarized here with merciful brevity, is merely one element in the continuing debate on the achievements of a painter and sculptor whose art always seems to fall some way short of completeness, even in its most perfect manifestations—and there is surely no reason why the judgments on his work should be any more conclusive than the work itself.

Little Dancer of Fourteen Years,
1878–81

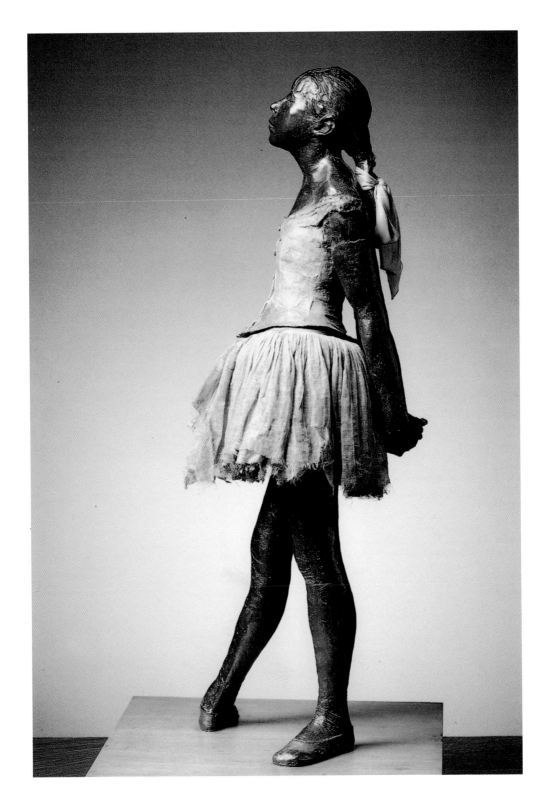

A Melancholy Grand Seigneur

In nineteenth-century Paris, artistic scandals were a well-estab-
lished feature of public life. The year 1857 had seen the indictment
of two major works of literature—Charles Baudelaire's *Les Fleurs
du Mal* and Gustave Flaubert's *Madame Bovary*—on grounds of
blasphemy and indecency. In 1863, Edouard Manet's *Déjeuner sur
l'herbe* had met with an extremely hostile reception from the public
and the critics, and his *Olympia* caused an even greater outcry
when it was exhibited two years later. Emile Zola's novel *Nana* was
condemned as pornographic in 1879, and in 1881 it was Degas'
turn to be subjected to similar treatment. As in the past, society
took umbrage at its own portrait, rejecting any attempt to probe
behind the glittering façade of contemporary reality. During the
Second Empire, Napoleon III and Baron Haussmann, the planner
and prefect of Paris, had embarked on a massive program of re-
development to turn the city into a modern metropolis. The mid-
century economic miracle had given work to the urban poor and
enriched the middle class, transforming the conditions of every-
day life and erecting new shrines—including the two world trade
exhibitions of 1855 and 1867—to the idols of consumer capital-
ism. These developments were accompanied by ugly conse-
quences, in the shape of corruption, profiteering, and prostitu-
tion, together with the systematic stifling of political opposition.
Paris became known as the boulevard and the brothel of Europe.
As the economy boomed, the newly widened avenues became a
platform for new forms of street life and ever more frenzied dis-
play. Flaneurs, bohemians, and dandies flocked to the cafés,
dance halls, and cabarets, where their miscellaneous needs were
ministered to by the *midinettes, grisettes, lorettes, cocottes,* and all the
other species of "female fauna" identified by the essayist Walter
Benjamin in his seminal study of the period.

The fashionable artists of the time, such as Hippolyte Flandrin,
Alexandre Cabanel, and Jean-Louis Forain—specializing in the
glamorous depiction of life as encountered on the Champs-Ely-
sées, in the salons of the new rich, or at the great trade exhibitions

Self-Portrait, 1857

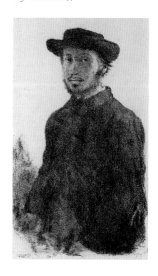

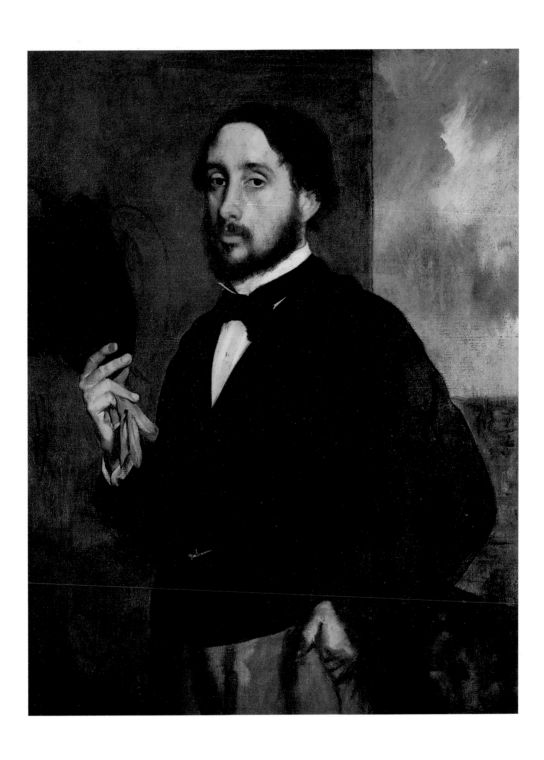

Self-Portrait, ca. 1863

—had nothing to fear from the public or the critics. But things were very different for those painters who sought to investigate *la vie moderne* in a more comprehensive sense, by portraying passersby, waitresses, absinthe drinkers, and whores. This latter category of artists included the two friends Manet and Degas, both from privileged backgrounds, who were among the first members of the Impressionist movement to address subject matter of this kind.

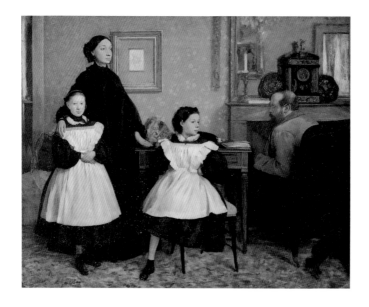

The Bellelli Family, 1858–67

Degas, the son of a wealthy banker, had grown up in a cosmopolitan, art-loving household. His earliest works were history paintings, executed in a style influenced by Ingres and Delacroix, and group portraits of his family, whose members were partly of Neapolitan and Creole descent. Having made his mark at the relatively young age of twenty-six with *The Bellelli Family* (illus. above), he went on to produce a whole series of remarkable portraits, taking friends, society hostesses, and other contemporaries as his subjects—only recently, he has been described as possessing "the highest degree of physiognomic intelligence to be found in the art of the nineteenth century."[3] From the mid-1860s, he turned to subjects of a specifically contemporary nature, such as horses and jockeys, café scenes, shopgirls parading on the boulevards, and

washerwomen toiling in backyard laundries. And the depiction of dancers, both on stage and behind the scenes, became a veritable obsession. These motifs served in turn as a basis for exploring more general themes: the relationship between the worlds of real and artificial experience, the inversion of traditional hierarchies of significance (elevating the trivial and/or trivializing the classical), and the sense of movement and speed that characterizes the modern age.

Degas' character was every bit as complex as his art. In some of his early self-portraits, he appears as a handsome but melancholy youth, vulnerable and introverted, his gaze fixed attentively on the viewer (illus. p. 114); yet in others, he depicts himself as a debonair young man about town, carrying a top hat and wearing an expression that seems quizzical or even blasé (illus. p. 9). A late self-portrait, made after 1895, shows him as prematurely aged, exhausted and sclerotic. This negative self-image is contradicted by photographs from the same period, in which he continues to appear as a formidable figure, with no outward sign of the hypochondria and the mood of resignation that overtook him when his sight began to fail at a relatively early age.

The contrariness of Degas' personality is reflected in the conflicting accounts of him by his contemporaries. At times, he exhibited the cussedness of a deliberate outsider, a peevish and cynical recluse, but as his letters show, he could also be a warm and loyal friend, and a patient dispenser of advice to younger colleagues. And his misanthropic outlook did not prevent him from regularly seeking the society of artists, wealthy businessmen, and aristocrats as an audience for the mordant wit to which his many recorded aphorisms bear witness. The poet Paul Valéry describes these occasions thus: "Every Friday Degas, faithful, scintillating, unendurable, enlivened Monsieur Rouart's dinner table. He scattered wit, gaiety, terror. He mimicked and he struck home, lavish with his maxims and his taunts, his tirades and his tales, all the traits of the most intelligent injustice, the surest taste, the narrowest and indeed the most lucid passion.... I can hear him now."[4]

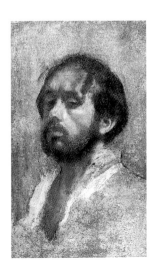

Self-Portrait, ca. 1863

Ballet: An Art in Decline

In the late 1860s, when Degas first became interested in ballet, he happened to be living near the rue Le Peletier, where the Paris Opéra was still housed in interim accommodation: its original building had been destroyed by fire in 1821, and the opening of Charles Garnier's dazzling new theater in the Place de l'Opéra did not take place until 1875, two years after the temporary structure had also burned down. From the outset, the artist was able to sketch behind the scenes and at rehearsals, as well as sitting in the auditorium—he had been a regular operagoer since his youth, and his musical friends provided him with the necessary introductions.

The first ballet pictures—such as the cunningly structured composition *The Ballet from "Robert le Diable,"* which is divided horizontally and lit from several angles (illus. opposite)—are conceived from the perspective of the ordinary spectator, and are closely akin to Degas' depictions of musicians and orchestras. Although they already reveal his eye for the magical world of the footlights, there is nothing to suggest that his attention will soon be directed to a single feature of this world: the body—the female body—in motion, viewed in strict isolation from other aspects and depicted in all its manifold variations. He begins with the strictly controlled and stylized movements of classical dance.

Perhaps paradoxically, just at the time when the greatest ballet painter of the day appeared on the scene, the ballet of the Paris Opéra entered a period of decline. The great era of Romantic ballet, lasting from the 1820s to the late 1860s, had finally expired: gone were the days of such star performers as Maria Taglioni, who perfected the technique of dancing on points, or Fanny Elssler, who introduced Spanish dance to the classical stage, or Carlotta Grisi, Fanny Cerrito, and Lucile Grahn. And the advent of the Ballets Russes, the revolutionary dance company founded in Paris in 1909, was still a long way off. At the Opéra, the only remaining survivors of the Romantic era were the former dancer Louis-François Mérante, now a choreographer and teacher, who was a

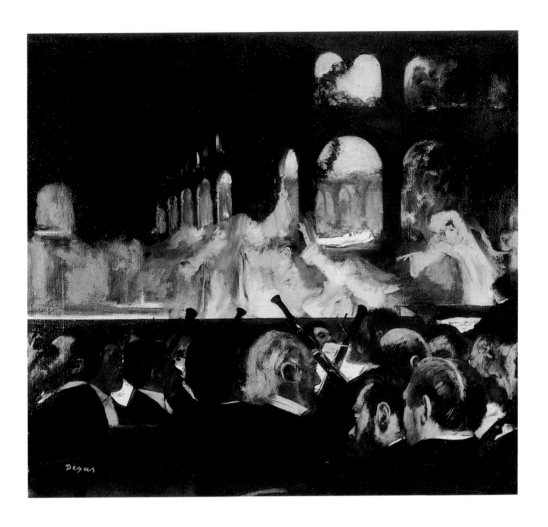

The Ballet from
"Robert le Diable," 1876

friend of Degas, and Jules Perrot, the erstwhile *maître de ballet*, a legendary figure who had created a sensation in St. Petersburg as the partner of Taglioni and lover of Grisi. Degas paid tribute to both these men in his pictures.

There were no prima ballerinas of real significance left in Paris: the few names that crop up in connection with Degas are scarcely worth mentioning. His ballet pictures feature only two or three *étoiles* and a couple of young pupils, together with the two male teachers, whose inclusion strikes an interestingly contemporary note in otherwise "timeless" scenes. But would Degas have been helped by the availability of an Elssler or a Pavlova as models? Surely not: for his purposes, names were irrelevant.

13

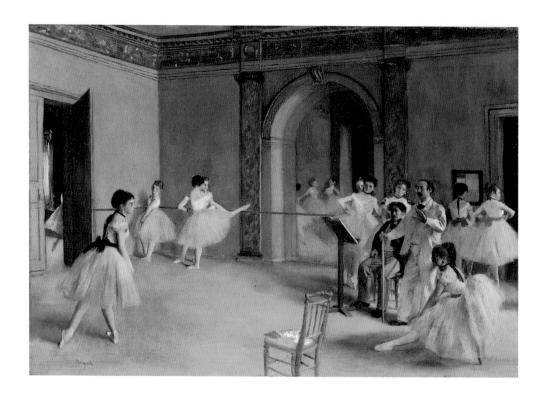

Gossamer Delicacy

We tend to think of charm as an ineffable quality that eludes definition and explanation. Degas took a different view. He set out to analyze every last nuance of movement and gesture, sitting in the wings at the Opéra and filling one sheet after another with drawings that he then took back to his studio for further processing. The writer Edmond de Goncourt was greatly amused by Degas' physical mimicry of the various movements and positions— the *ports de bras*, *pliés*, *battements*, and so forth—which he could reproduce with astonishing accuracy. And from 1871 on, the results of this close study could be inspected in his paintings, combining crystalline precision with gossamer delicacy to evoke all the evanescent charm of the ballet.

above
Dance Class at the Opéra,
1872

facing page
Dancer Adjusting Her Slipper,
1880—85

The rehearsal scenes in the early ballet paintings, of 1871–72, are set in coldly neoclassical surroundings, with high doors or arches that open out to reveal windows, mirrors, or further rooms. In *Dance Class at the Opéra* (illus. opposite), a group of girl dancers—dressed in white bodices and knee-length skirts, with contrasting colored sashes, tied at the back, and black velvet chokers—

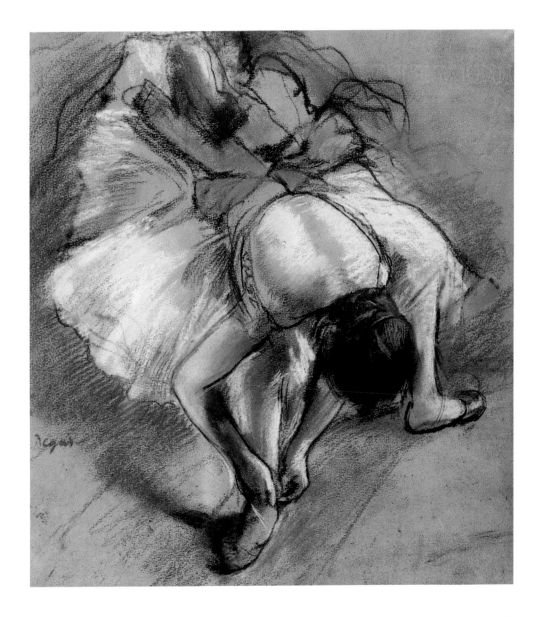

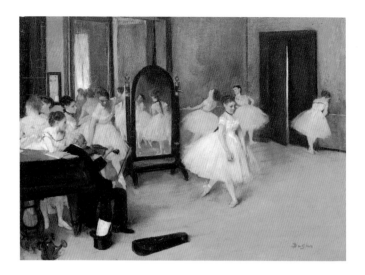

Dance Class, 1871

Violinist, ca. 1871

forms an open semicircle around the teacher, who is leaning on a long stick and closely observing the graceful performance of the prima ballerina. In another picture (illus. above), an aged violinist is supplying the necessary musical accompaniment, scraping out a tune with almost audibly thin tone. A number of details immediately catch the eye: a violin case, a section of a piano, cut off by the edge of the picture, or a reflection in the mirror, a picture within a picture, revealing something of the goings-on outside our field of vision, but in a manner that appears less than reliable. Looking more closely at these paintings, one discovers a series of further incidental touches that are less obvious but equally delightful: the fine line of light from a door standing very slightly ajar, the transparent quality of the fan in a girl's hand, or the exchange of glances, professional but faintly suggestive, between the dance master and the prima ballerina.

These early rehearsal pictures owe their discipline and purity of line to Ingres, and their fragrant elegance to the *fêtes galantes* celebrated by eighteenth-century painters, such as Lancret, Watteau, and Fragonard. Thus the beginnings are restrained and unspectacular, remaining within the bounds of convention. But very soon, a sharp gust of wind blows over the canvas, and the diagonal line asserts itself as the predominant compositional device, following

the pattern adumbrated in the jockey paintings. At the same time, Degas begins to experiment with unfamiliar angles and with the use of overlapping images, an effect, derived from Japanese art, that quickly establishes itself as part of his repertoire.

In *The Rehearsal* of 1874 (illus. below), the body of one of the dancers is almost obliterated by the line that continues via the staircase and the legs of the girl descending the steps above her. But despite this discordant, strikingly "modern" touch, the picture remains a miracle of formal and chromatic harmony. The congruence of the spiral staircase with the balloon shape of the skirts is especially appealing, and it is also fascinating to observe how the sunlight falls across the scene and lends a shimmering vibrancy to the details—the white clouds of gauze, the rose-pink sashes, the patches of shadow on the wooden floor, and the flecks of scarlet, golden red, and green in the hair and the clothes.

In compositional terms, *The Dance Class*, completed in 1876 (illus. p. 19), strikes a far more dramatic note. Here, the group of

The Rehearsal, 1874

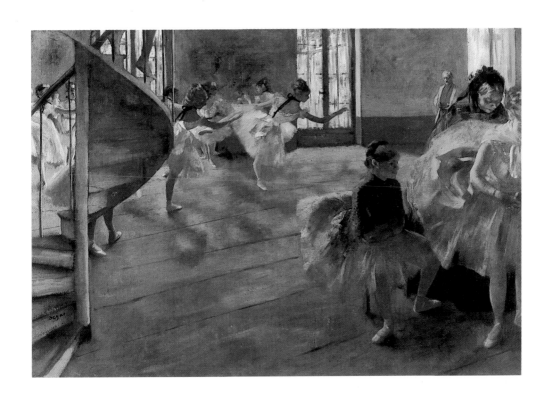

dancers is arranged in a loosely connected row that extends across the room and surrounds the dance master and his star pupil with a gently undulating movement. Some of the girls are standing, while others sit, watching attentively or chatting idly to one another and fiddling with their costumes. In the background, the inevitable "stage mothers" watch jealously over them. The gaze also alights on a number of further details: the can of water used to lay the dust on the dance floor, the little dog, the grainy light at the window, and the young girl seated on the far left, scratching her back. These are not mere scraps of narrative garnishing, but precisely calculated effects inserted by the hand of an expert, which suggests or even presupposes that this picture, like many others, was composed in the studio on the basis of an extensive collection of preliminary studies. From time to time, moreover, Degas employed professional models for the dancers, and prevailed upon his housekeeper, Sabine Neyt, to pose for the "stage mothers."

Degas systematically explores the possibilities of each motif in a wide variety of techniques. This is especially the case with works, such as *The Dance Class*, that contain a large number of figures. For example, he made oil and charcoal sketches of the girl scratching her back (illus. right), who also crops up as a minor figure in several further pictures. The dancing master, Jules Perrot, was the subject of numerous studies that originated well before the painting. The figure of the solo dancer can be traced back to a drawing made in 1872. A depiction of a dancer gracefully adjusting her slipper, originally sited just next to the girl with the fan by the piano, but subsequently overpainted, has survived in the form of two sketches, in oil and pencil (illus. above). The following year, Degas painted a completely new version of the picture, placing even more emphasis on movement.

This process of dogged repetition, endlessly varying a single theme, motif, or compositional device, became a central feature of the work of Degas. His love of experimentation flourished in the ballet paintings and grew into an obsession. "One must repeat the same subject ten times, a hundred times," he wrote. "Nothing in art, not even movement, must seem an accident."[5] Elsewhere, he explains: "It is all very well to copy what one sees, but it is much better to draw what one sees no longer except in memory."[6]

Dancer Adjusting Her Slipper,
1873

*Dancer in Profile Turned
to the Right,* 1873–74

facing page
The Dance Class,
1873 and 1875–76

18

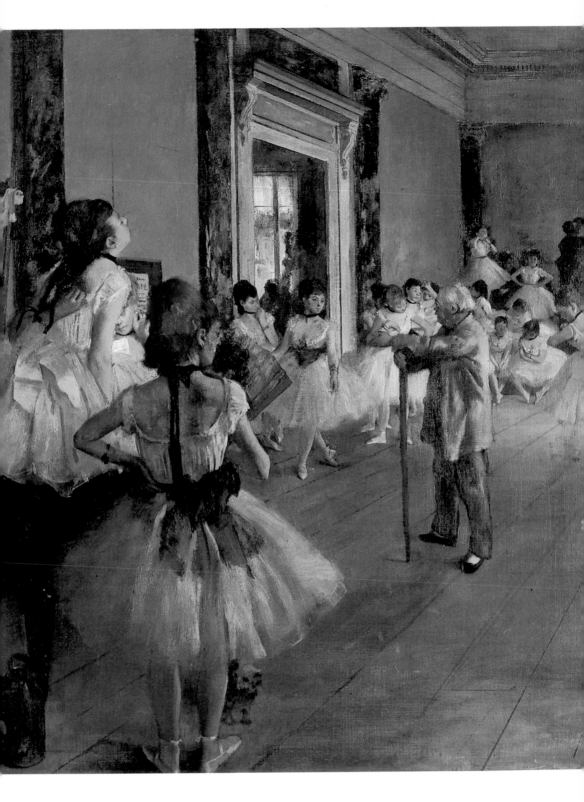

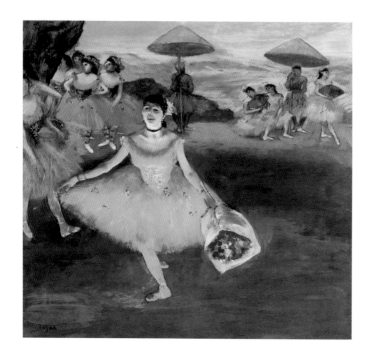

Fragmenting the Image

Degas painted rehearsals far more often than performances, probably because the former offered greater potential for variation. His aim was certainly not to illustrate specific ballets or productions, and the only significant difference between his renderings of stage performances and his images from the rehearsal room lies in the treatment of the light. In the rehearsal scenes, artificial light is combined with the daylight that filters through the windows to form a soft, delicately nuanced twilight, interspersed with flickering shadows; but on the stage, the light is bright and harsh, casting a much harder shadow and whitening the dancers' faces, almost as if they were wearing clown makeup (illus. above). No attempt is made to show the dancers performing in public in a spatial situation different from that of the rehearsal pictures—for example,

Orchestra Musicians,
1870–71 and 1874–76

20

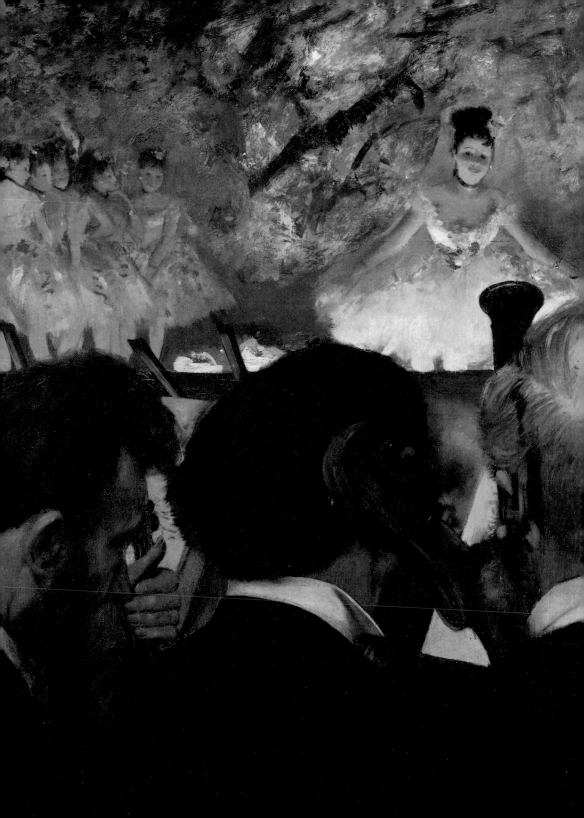

by presenting soloists or groups of figures from a frontal viewpoint, as if the artist were sitting in the audience. On the contrary, they are seen from particularly odd angles that are almost impossible to understand in naturalistic terms—either from very low down, in the orchestra pit, or from very high up and at an oblique angle, from a box at the top of the proscenium arch. These pictures often have the appearance of photographs, selecting specific details from the events taking place on stage and focusing sharply on individual figures.

Thus, the figure in *The Star* (illus. below) dominates the entire picture as she stands at the cutoff front of the stage, engaged in a gracious gesture of farewell. In another example, dancers executing a *pas de deux* are shown tripping forth from the wings into a space that appears almost completely undefined (illus. p. 33), while in *Ballet* (p. 25) the prima ballerina performing her *pas seul* leaps toward the edge of the orchestra pit with a degree of gusto that one contemporary critic described as positively alarming, remarking that if he had been the conductor of the orchestra, he would have been rushing to her aid.[7] His response is understandable: the exquisite creature is poised on one leg, in the center of an open, undefined space whose vertiginous slant, combined with the effect of the light radiated through her costume, makes her seem as weightless and fragile as a small bird. Revealingly, this work was bought by Degas' fellow artist Gustave Caillebotte, noted for his drastic use of perspective. The eccentricity of the viewing angle is taken to particular extremes in pictures such as *The Green Dancer*, where the figures appear to float on the green spray of their outspread skirts (illus. p. 24). In a further instance, the arm movements of a group of dancers are so heavily foregrounded that only the upper body of a single dancer is seen in full—the arms of her companions vaguely recall the tentacles of an octopus (p. 27). The background generally consists of random details of the scenery, augmented by glimpses of members of the *corps de ballet* waiting in the wings or leaving the stage; the audience is either omitted altogether, or referred to obliquely by incidental descriptive elements, such as a large fan held in front of a female profile.

It is this predilection for fragmenting the image that constitutes the specifically modern element in the work of Degas.

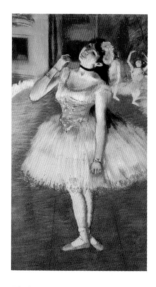

The Star, 1879–81

facing page
At the Ballet, ca. 1880

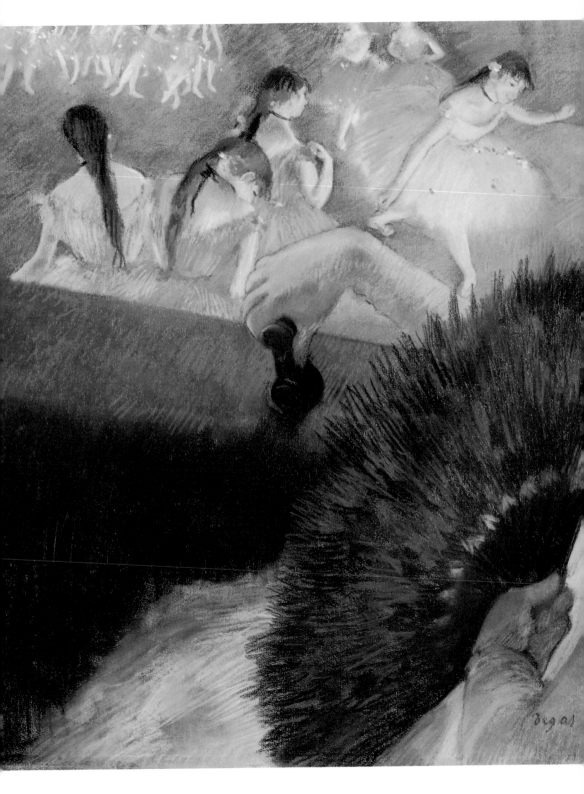

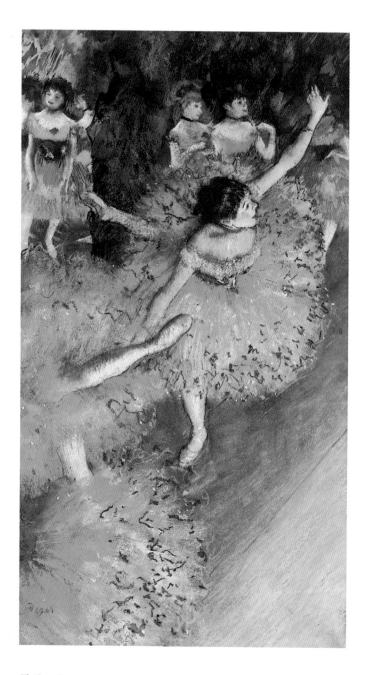

The Green Dancer, ca. 1880

Ballet, 1876–77

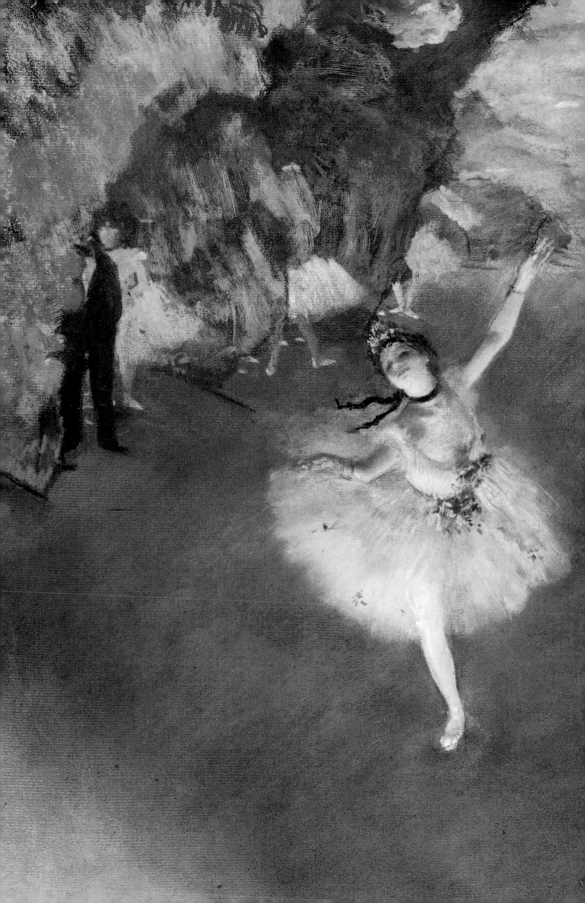

Adopting an entirely new approach to the subject of dance, he refused to base the composition of his ballet pictures on the tediously frontal style of choreography and performance that prevailed at the time; parades of theatrical glitter and glamour failed to arouse his interest. Yet despite the absence of such concessions to popular taste, his depictions of dancers attracted a huge amount of attention. Their appeal lies in the rendering of the fleeting moment. At the same time, their formal elegance conveys a sense of the artificiality specific to ballet, as an activity involving an exceptional degree of discipline and stylization. And perhaps this aspect allowed the ballet audience of the time to retain its illusions.

How do the dancers of today regard these images? They see Degas' paintings as astonishingly modern, anticipating the sophis-

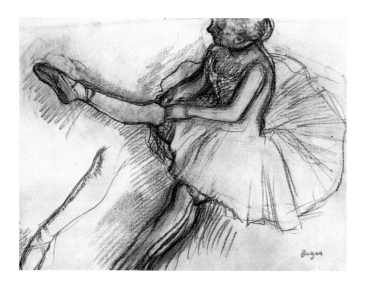

Dancer Adjusting Her Tights, ca. 1880

ticated ballet photography of our own era, and they emphasize the accuracy with which he reproduces the standard repertoire of gesture and movement. But they also point, with some amusement, to the mistakes in a number of the sketches, showing poses that are inept or sometimes plain wrong—although it is unclear whether the fault lies with the artist, or the youthful dancers, or the techniques of nineteenth-century ballet, which were undoubtedly less sophisticated than those of today.

Dancers on Stage, ca. 1883

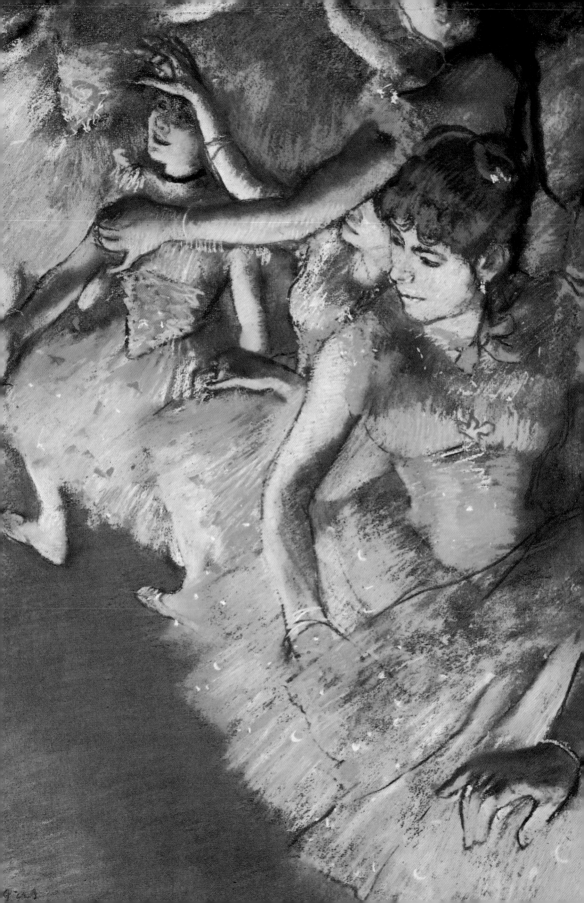

Grace and Exertion

Degas' pictures teem with realistic aperçus, brief snapshots in charcoal, chalk, and pastel, of dancers scratching their backs, adjusting their tights, rubbing a sore ankle, arching their necks and yawning with exhaustion, sitting or lying in attitudes that convey a deeply felt ennui and loneliness (illus. pp. 28–31). As well as showing the magic of ballet, the artist also reveals the toil and sweat: indeed, these aspects are almost more prominent than any other.

Dancers Resting, 1881–85

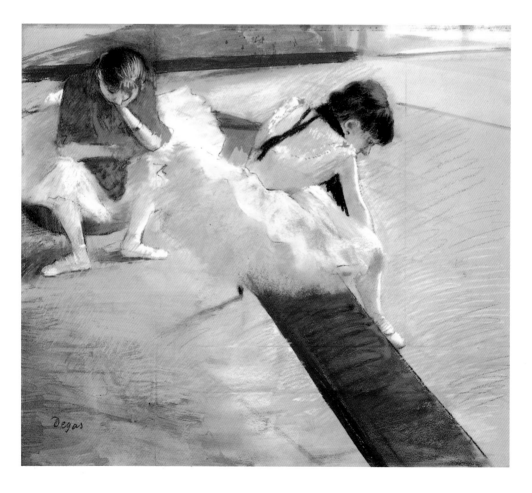

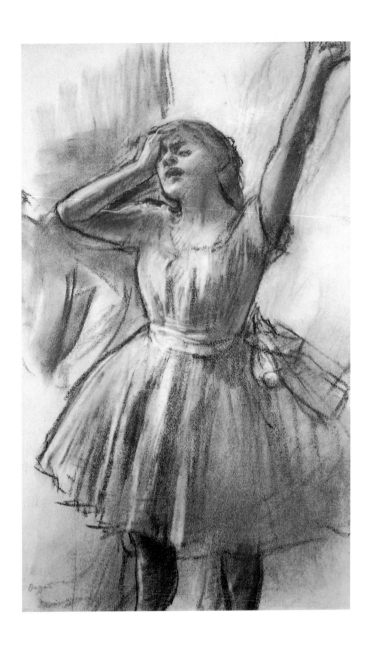

Dancer Stretching,
1882–85

Although these insights are remote from any social criticism of child labor, Degas consistently refrains from glorifying physical pain as a necessary sacrifice in the cause of art, or from rendering straightforward tributes to female beauty. Instead, one finds the rare moments when these corseted creatures are temporarily un-masked, captured in artistic exercises of the utmost precision.

Rilke, who grasped the "fluttering mood" of these pictures very well, wrote in 1898: "They [the dancers] stand around, usually in groups ... fastening their slippers or adjusting their cloudlike skirts; with the sadness of birds who have lost their wings just when they were on the point of making further progress, but have not yet learned to use their legs."[8]

The figure in *Little Girl Practicing at the Barre* (illus. opposite) is still so childlike that one feels oneself wanting to take her away from the exercise bar, which is far too high for her, and fill her up with cake and lemonade. But she would object violently to this, and so would Degas. At this particular moment, her thoughts are entirely taken up with the correct positioning of her limbs, which she is inspecting with an expert's critical eye. Her pouting expression, meticulously recorded by Degas, indicates that she is dis-

Waiting, ca. 1882

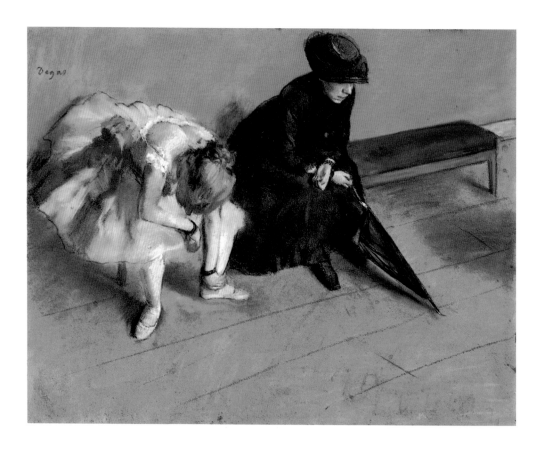

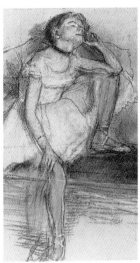

Dancer Resting,
ca. 1880; detail

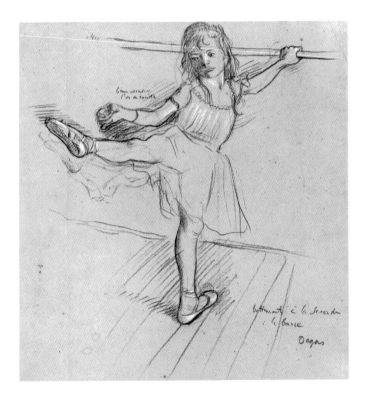

*Little Girl
Practicing at the Barre,*
1878–80

Seated Dancer, Head in Hands,
ca. 1878

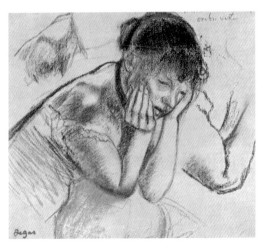

satisfied with the result: she is telling herself that she must keep on practicing and spurn all offers of sympathy.

Nevertheless, all this self-punishing exertion is conveyed with the grace of a consummate draftsman—a draftsman who rejected Impressionism because he was neither willing nor able to abandon line. By this point, he has relinquished the hard, crystalline style of Ingres, and his drawings, pulsating with the warmth of the human body, exhibit a wide range of expressive nuance—the lines are alternately powerful and confident, or sensitive and hesitant, combining bold contouring and shading with filigree-like calligraphy and nervous squiggles. Their effect is intensified by the varieties of tinted paper, in shades of off-white, gray, brown, light blue, and salmon pink, and by the inclusion of white highlights. But perhaps the most outstanding technical feature is the use of pastels, which gives the ballet drawings their special quality of luminosity and lightness. At times, their sheer beauty leads one to question their verisimilitude. Can such works really be accurate portrayals of reality? Degas resolved this dilemma by describing his aim as "to bewitch the truth and give it the appearance of madness."[9]

Contemporary sources show that ballet was not only physically strenuous; the dancer's entire life was often downright miserable. The young pupils were often referred to as "rats," a term whose origins date back as far as the fifteenth century but which achieved wide currency only from about 1800 on, as the popularity of ballet grew. The appellation reflected the dire hardships suffered by the little girls, whose ambitious parents—mainly shopkeepers, artisans, office workers, and other members of the impoverished lower-middle class—enrolled them at the Opéra ballet school at the age of seven or eight, in the hope that they would eventually bring home enough money to support the family. After three years at the school, with lessons lasting from nine in the morning to four in the afternoon, their potential would be assessed, and in the event of a positive outcome, at the age of ten or eleven they could expect to receive an annual salary that was difficult to earn by any other means. But only a few members of each class were hired; the others were expelled without further ado. The successful candidates then underwent a further eight years of training, with the

Two Dancers Entering the Stage,
1877–78

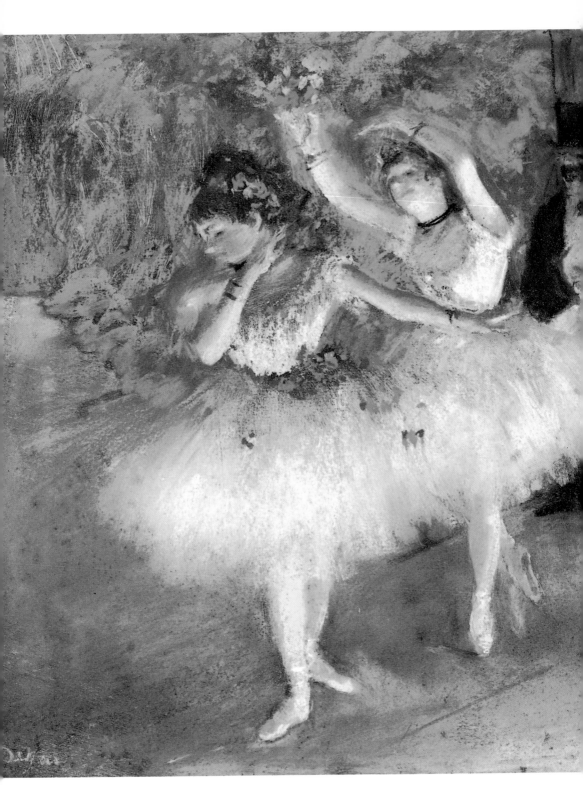

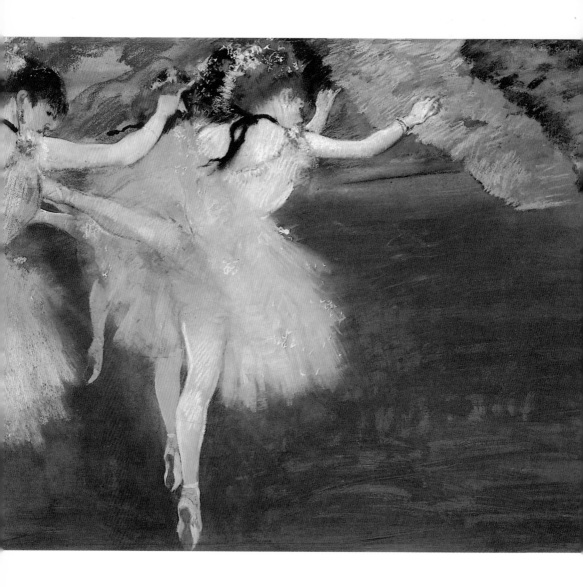

prospect of achieving star status and doubling their salary if they
passed all the necessary examinations. Until then, they remained
the "rats" — "the waifs of the theater, wearing other people's dis-
carded and cut-down clothes, insufficiently fed, and always begging
a few sous with which to buy sweets."[10] Other accounts paint a
similarly grim picture, and even speak of child prostitution, which
was almost a logical extension of such exploitation. Ballet training

Dancers, White, ca. 1878

34

had always been a harsh business, but under these circumstances, it became sheer forced labor.

The full extent of this misery is conveyed in a few of Degas' pictures, with a degree of sympathy that is otherwise rare in his art. It is apparent, for example, in the pastel *The Mante Family* (illus. below), although the family in question was not in fact particularly poor: the mother in the portrait was married to a bassoonist in the Opéra orchestra, and her two small daughters—the seven-year-old Suzanne and the even younger Blanche—later had unswervingly successful careers that eventually took them to teaching posts at the school.

One of the few identifiable models used by Degas was the Belgian girl Marie van Goethem, who posed for the wax sculpture discussed at the beginning of this essay, *Little Dancer of Fourteen Years* (illus. p. 7), and whose relationship with the artist was the subject of much speculative gossip. Van Goethem was the daughter of a laundress and a cobbler, whose home was near Degas' apartment. Like her two sisters, she was a pupil at the ballet school, and she later became a much sought-after model. Degas drew her many times from every conceivable angle, clothed and unclothed, in charcoal, black chalk, and pastel, as a preparation for the three-dimensional experiments that resulted in the above-mentioned sculpture, dressed in real garments, a nude version of the same figure, and a number of further wax figurines of dancers.

Degas also made a large number of drawings of the girl's face, whose supposedly "atavistic" features—the protruding chin and low forehead—he found intriguing for what he called "typological" reasons.[11] The critics seized on this aspect as a welcome excuse to indulge in zoological invective, further encouraged by the artist's decision to display the figure in a specially constructed glass case, of the kind normally encountered in museums of natural history rather than in art exhibitions. But his quasi-scientific attitude to the subject matter did not prevent Degas from approaching it in a poetic spirit as well: in one of his occasional sonnets he praised Marie van Goethem as a "winged urchin" and enjoined her "to retain in the palace the race of her street."

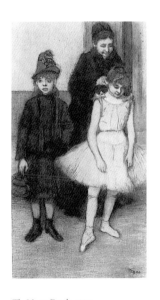

The Mante Family, 1884

Stage Mothers and Backstage Gentlemen

A number of Degas' pictures refer to the "stage mother," a fig-
ure—much caricatured at the time—who played a central part
in the lives of young dancers. Sometimes one discovers the
mothers only at a second glance, seated on the right of the canvas
and forming a solid black silhouette next to the shimmering white
line of dancers, or slumped in front of the dark maw of a specta-
tor's box. Another of these *mamans*, fussing over her daughter's
bodice in the dressing room, seems almost to efface herself by
shrinking into the shadows, yet her piercing stare, directed at the
viewer rather than at the sullenly indifferent object of her minis-
trations, is nevertheless mildly alarming to the beholder who
stumbles upon her unawares. One is startled in much the same
way by suddenly finding the reflection of the top-hatted customer
in the mirror next to the infinitely forlorn-looking figure of the
cashier in Manet's *Bar at the Folies-Bergères* (illus. opposite).

Another stock figure is the "patron," portrayed in a variety of
situations—standing like tall, bulky ravens, tailcoated and top-
hatted, in the midst of the dancers as they wait nervously in the
wings; hovering in predatory groups at the foot of the stairs, ready
to catch the girls on their way down; chatting to the ever-vigilant
stage mothers by the dressing room door, or talking to the girls
themselves. The expressions of these backstage gentlemen are
partly hidden, for they are rarely seen full-face, but their poses and
gestures are eloquent enough in themselves, betokening a mixture
of embarrassment, benevolence, and proprietorial smugness (illus.
pp. 37–41). The portrayals—for example, in *The Curtain* (illus.
this page)—often have a gently mocking quality, and the figures
are not demonic and menacing, unlike in Manet's renderings of
the same subject. But these black shadows are very far from being
charming cavaliers, and their omnipresence amid the tinsel and
glitter makes it quite clear who is observing whom.

These men wielded considerable power: as the *abonnés*, who
played a major part in financing the Opéra, they were in a position
to determine the choice of works to be performed, and to in-

The Curtain, ca. 1880; detail

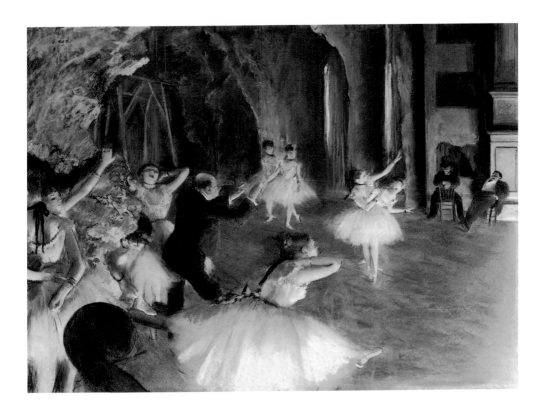

The Rehearsal on Stage, 1874 (?)

Edouard Manet, *Bar at the
Folies-Bergères*, 1881–82; detail

sist that ballet sequences be included even in an opera such as
Wagner's *Tannhäuser*, where such additions were out of place. They
also had rights of access to all the parts of the theater otherwise
reserved for the members of the ballet company—the rehearsal
rooms where the dancers practiced during the day, the rest areas,
and even the changing rooms. The done thing, after renting one's
box, was to hire a ballet "rat" to go with it, in the hope that her
youth would revive the flagging performance of her aging para-
mour.

This phenomenon is documented in the novels and memoirs
of many nineteenth-century French writers, ranging from Balzac
to the Goncourt brothers. Degas' close friend Ludovic Halévy,
well known as the librettist of Bizet's *Carmen* and Offenbach's *La
Belle Hélène*, wrote a number of satirical treatments of the subject,

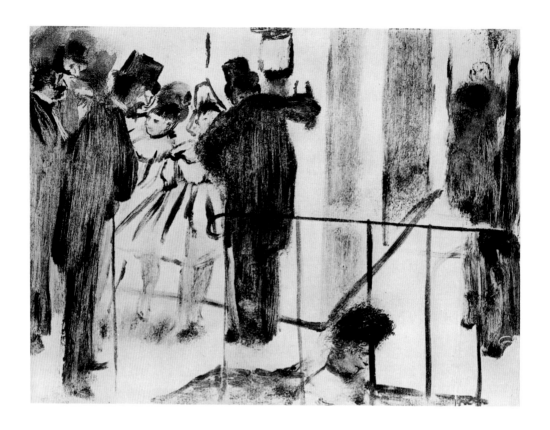

including *Monsieur et Madame Cardinal* (1872) and *Les Petites Cardinal* (1880), in which Madame is portrayed as an archetypally dreadful stage mother, endeavoring but signally failing to protect the virtue of her dancing daughters, Pauline and Virginie—the one becomes a high-class whore, and the other is married off to a rich aristocrat, before finally running off with a singer. In 1880, Degas made a series of thirty-three monotypes based on the two stories, but the illustrations met with the disapproval of Halévy, who had little understanding of visual art; after vanishing back into the artist's studio, the prints resurfaced in 1928 and were published in a facsimile edition ten years later.

The *Cardinal* illustrations (illus. pp. 38–40) were a particularly successful exercise in monotype printing, a technique that Degas had already used on a number of previous occasions. The figures are wittily observed, and the depiction is remarkably free and

"Pauline and Virginie talking to admirers," 1880; illustration to Ludovic Halévy's *Cardinal* stories

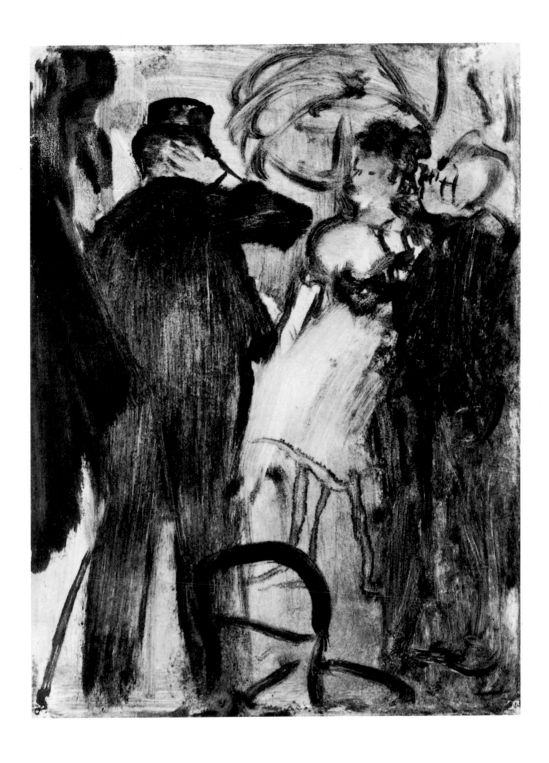

"The Marquis Cavalcanti was the one who turned round most often,"
1880; illustration to Ludovic Halévy's *Cardinal* stories

"Dancers leaving their
dressing rooms," 1880;
illustration to Ludovic Halévy's
Cardinal stories

spontaneous, jumping rapidly from one scene to another in a
manner that appears almost cinematic. Unlike his fellow artist
Jean-Louis Forain, who exploited the *abonné*/dancer theme as a
source of dramatic, sentimental, and titillating effects, Degas ob-
serves the whole game with an ironic detachment that also com-
municates itself to the viewer, who is invited to regard the frock-
coated fauns with mildly contemptuous amusement.

Quite apart from their thematic significance, the "backstage
gentlemen" are also a brilliant formal device. The black, pillar-
like figures have an important anchoring function, supplying the
necessary contrast to the delicate, airy forms of the dancers and
the massed colors of the curtains and scenery. A similar purpose is

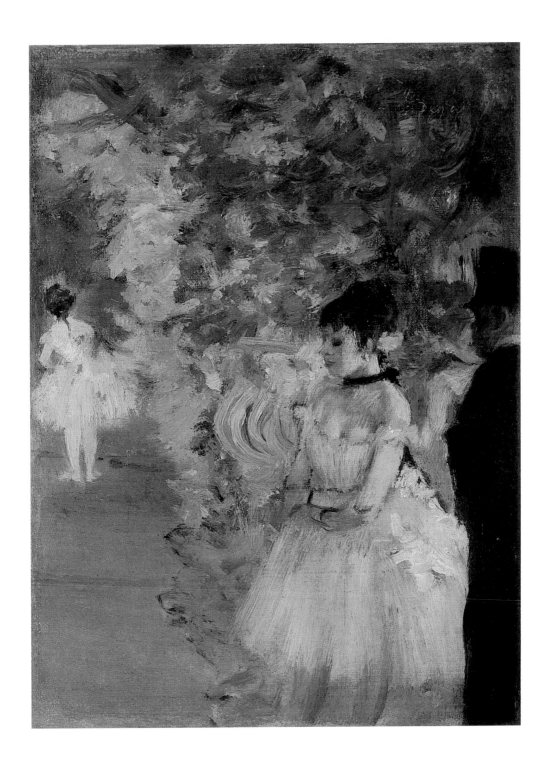

Dancers Backstage, ca. 1875

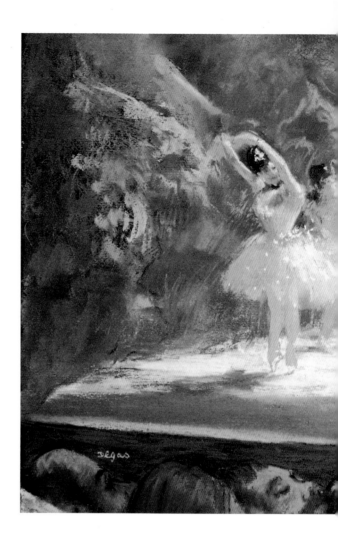

On Stage I, 1876

42

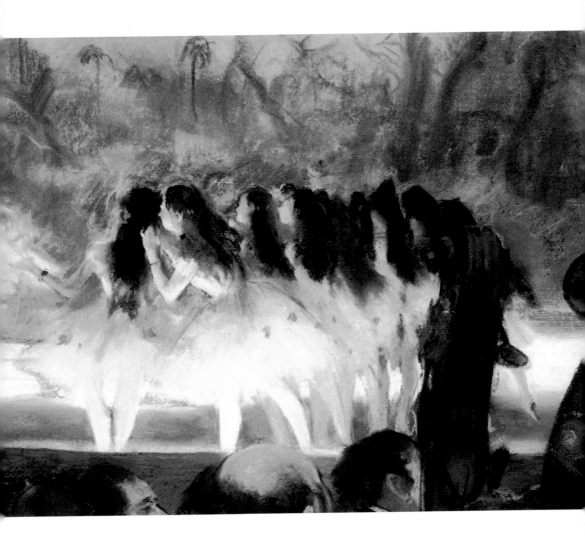

Ballet at the Paris Opéra, 1877

served by the necks and the huge scrolled heads of the double basses that rise up from the orchestra pit in a number of the theater pictures (illus. pp. 42, 43) and provide a striking visual connection between this dark nether realm and the brightly lit stage — although the manner in which the instruments stand out against the dancers' legs and skirts suggests that they are also intended to be seen as symbols of potency.

The stage mothers were equally omnipresent figures in the ballet world. As a rule, they were jealous guardians of their daughters' virtue, but in some cases, they were known to act as

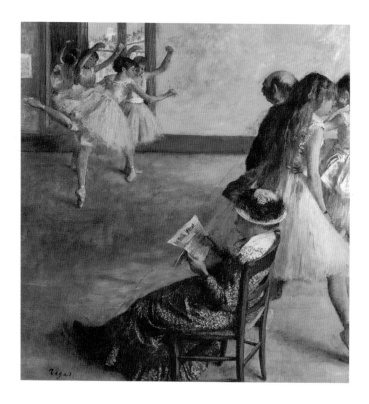

procuresses, openly cooperating with the "gentlemen." Writers such as Halévy often held them up to ridicule: "Moving hither and thither about the stage, in a state of nervous agitation, are the *coryphées* and the members of the quadrilles.... Then, all around, restless, bewildered, breathless and purple-faced, are mothers, mothers, and yet more mothers—more, I am sure, than there are dancers!"[12] But Degas, even in the *Cardinal* illustrations, avoided poking fun at the mothers, who are portrayed as stolid, simple women, sitting patiently in the rehearsal rooms, wrapped up in thick coats and presenting a stable contrast to the whirling figures of their daughters. Compared with the drab outfits worn by most of the mothers, the blue-and-white lace-trimmed dress of the seated woman in *The Dance Class* (illus. above) seems positively sparkling and sophisticated. The offbeat contrast between the dancers and the figure reading the newspaper makes this an altogether fascinating picture, which manages to juxtapose and reconcile two quite distinct worlds.

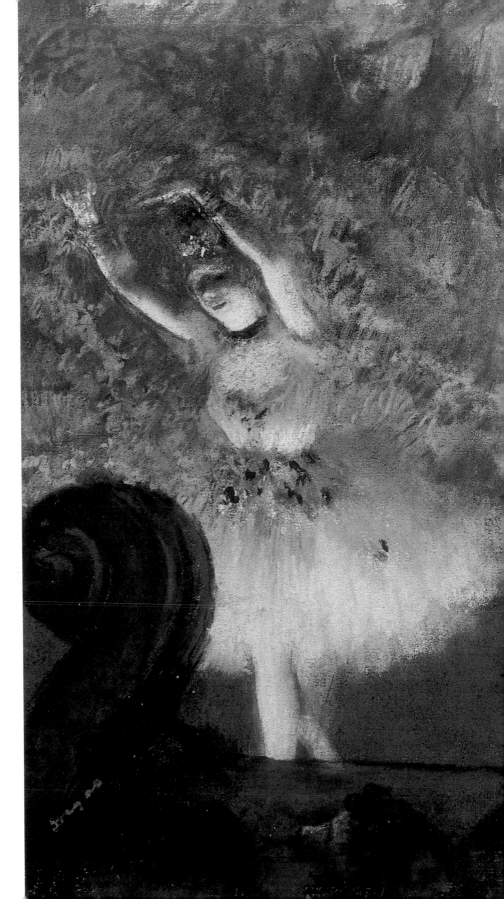

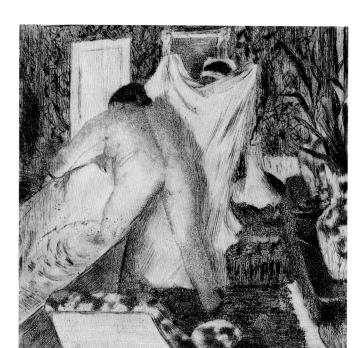

Leaving the Bath, ca. 1882;
18th state

Experimental Passions

According to legend, one night in 1882, when a storm forced him
to stay overnight at the home of the industrialist and art collector
Alexis Rouart, Degas picked up a copper plate that happened to
be lying around and began scratching at the surface with a lamp
filament. He took the drypoint etching home and continued
working on it, using this same "crayon électrique" to produce no
less than twenty-two states and forty-three proofs of the print,
titled *Leaving the Bath* (illus. this page).[13]

This eagerness to experiment, combined with a continual
striving for perfection, led Degas to try out almost every technique
available, ranging from etching and lithography to sculpture and
even photography. In the depictions of dancers and women at

Leaving the Bath, ca. 1882;
4th state

their toilette, he made particularly frequent use of two further media, monotype printing and pastel drawing, both of which have a somewhat hybrid character—the one is a halfway house between drawing and printmaking, while the other calls upon the artist to balance the respective claims of line and color.

Monotypes are made by painting an image on a plate of copper, zinc, or glass and transferring it to a sheet of paper. This absorbs all or nearly all the color, which means that only a single print can be made. Alternatively, the image can be created by inking a plate and then wiping the surface with a rag (Degas often used his fingers) to produce the white areas. The two processes can also be combined, a procedure whose very complexity appealed to Degas. In some cases he even made a second, much fainter print of a monotype and used this as the ground for a pastel drawing. His experiments in monotype printing began in 1874 and achieved

The Name Day of the Madam,
1876–77

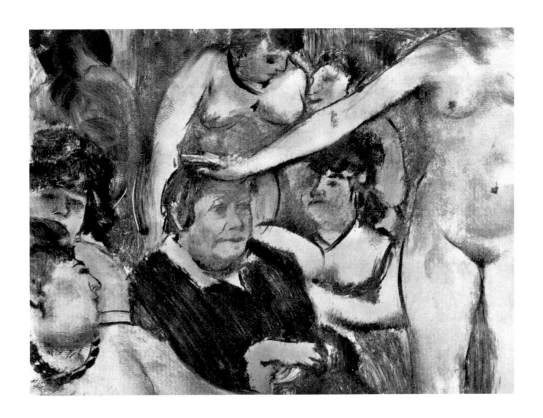

especially striking results in the *Cardinal* illustrations (1880; illus. pp. 38–40), the brothel prints (1876–85; p. 47), and the depictions of women washing or drying themselves (1878–90; pp. 71, 90, 91).

As for pastel drawing, Degas is one of the great masters of a medium that he revived almost single-handedly after its fall from popularity toward the end of the eighteenth century. Its attraction for him was obvious, as a technique that allows the artist to revel in color but nevertheless requires a very strong sense of line and structure. As an inveterate perfectionist, he also valued the flexibility of pastel, which allows the artist to correct the drawing at will. It is likely, moreover, that his failing eyesight led him to appreciate the impasto that results from fixative being applied to each layer of dusty pigment. At all events, in many of his late pastels of dancers and—especially—female nudes, he managed to invest the technique with a hitherto unsuspected passion and drama.

The ingenious combination of different techniques is one of the outstanding features of Degas' art: "Constantly moving between pastels and tempera, from using turpentine-thinned color on oiled paper to pastel mixed with tempera on a monotype, Degas may have been able to recapture something of the spirit and alchemy of the craftsmen-artists of the Renaissance, as much technicians as they were creative artists."[14] Imposing no limits on his curiosity, Degas the "alchemist" pursues every idea and impulse that occurs to him, even to the extent of exposing his pastels to strong sunlight in order to bleach the image, or of blowing steam over the surface to moisten the color and obtain a smeared or washed effect.

The critics of the day wondered whether the inspiration for *Little Dancer of Fourteen Years* might not have come from a wax figure of a saint in Naples, where Degas frequently traveled to visit relatives, or possibly from an anatomical model of the type for which Italian craftsmen were especially noted, or even from Madame Tussaud's waxwork museum in London. These speculations ignored the fact that, for a painter interested in the human body, wax was the obvious material of choice. After exhibiting the figure, Degas did a considerable amount of modeling, but purely for his own satisfaction. When he died, approximately 150 small wax and clay sculptures—many of them severely deteriorated—

Dancer Looking at the Sole of Her Right Foot, 1895–1900

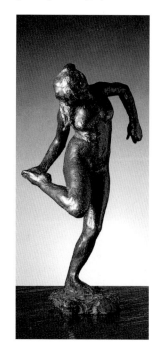

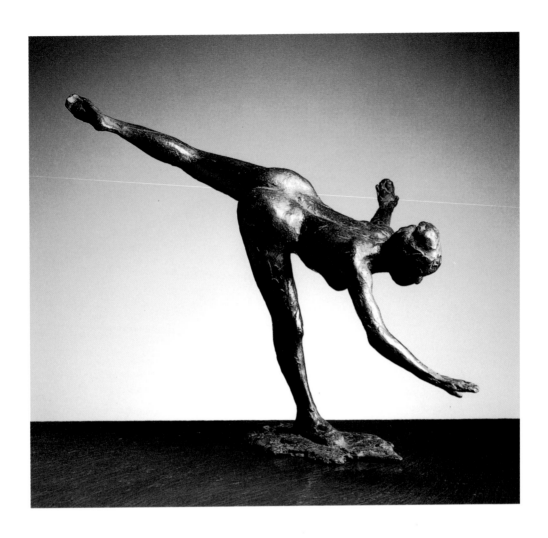

First Arabesque Penchée,
1892–96

were found in his studio. Seventy-four of these were subsequently cast in bronze (destroying the wax model in the process) and revealed to the art world for the first time in 1921. The sculptures, barely twenty inches high, deal with a variety of subjects, including the horse and the female nude, but the main focus of interest is the dancer, as Degas endeavored to articulate the movements of ballet in three-dimensional terms. Figures such as those in *Dancer Looking at the Sole of Her Right Foot* or *First Arabesque Penchée* (illus. pp. 48, 49) exemplify the kind of complex, spatially expansive balance that

49

the artist sought to achieve. These boldly conceived sculptures embody an exquisitely precarious tension between the dynamic and the static, yet their delicacy also endows them with great charm, heightened by the impressionistic treatment of the surface.

Long before the advent of Cubism and Futurism, Degas investigated the possibility of employing analytical methods in painting. In one of his notebooks (the entry probably dates from 1879 or 1880), he gave the following summary description of these aims: "To carry out simple operations, such as drawing a profile that would not move, moving oneself, up or down; the same for a whole figure, an item of furniture, an entire room.... Finally, to study a figure or an object, no matter what, from every possible perspective."[15]

At this point, the artist's photographic gaze, as seen in the "close-up" portrayals of dancers, takes on an almost cinematic quality, which becomes particularly apparent in the ballet friezes and pastels, and also in the later boudoir pictures. Under the influence of Eadweard Muybridge's sequential photographs of moving animals (but not those of human subjects, which he saw only much later), Degas became one of the first French painters to experiment with this new way of seeing and representing reality. His method of working accords with the principle of seriality found in the better known work of Monet, who, in his images of wheatstacks, Rouen Cathedral, and water lilies, repeatedly painted the same subject in different lights and at different times of the year. Like Monet, but starting out some ten years earlier (in 1880, as opposed to 1890, when Monet produced his first "Wheatstacks"), Degas systematically investigated a limited range of preferred themes. But instead of concentrating on static objects, he analyzes the poses and movements of dancers, breaking them down into single moments that are then reassembled into coherent sequences with the dynamic character of film. Instead of being frozen and isolated, the gesture becomes flowing and infinite—and inherently ephemeral.

Dancers in the Wings,
1878–80

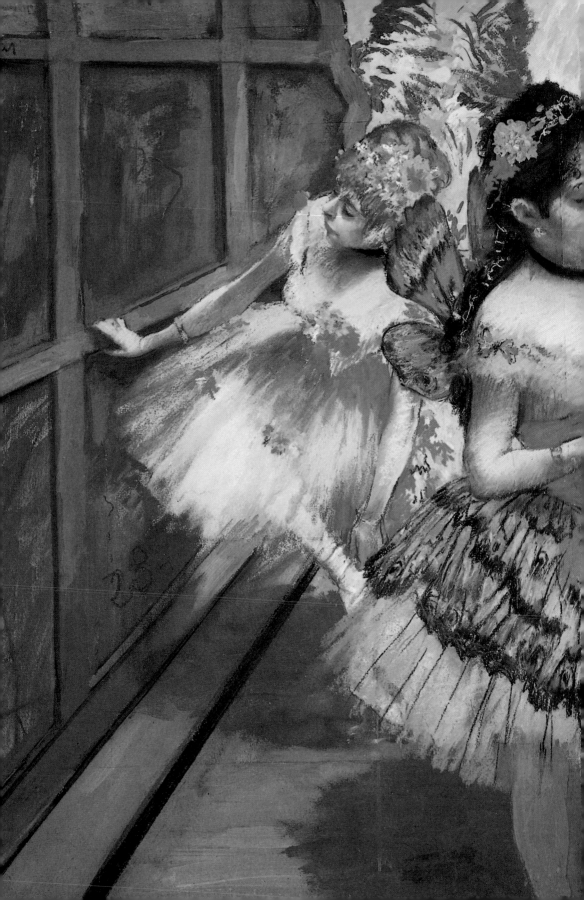

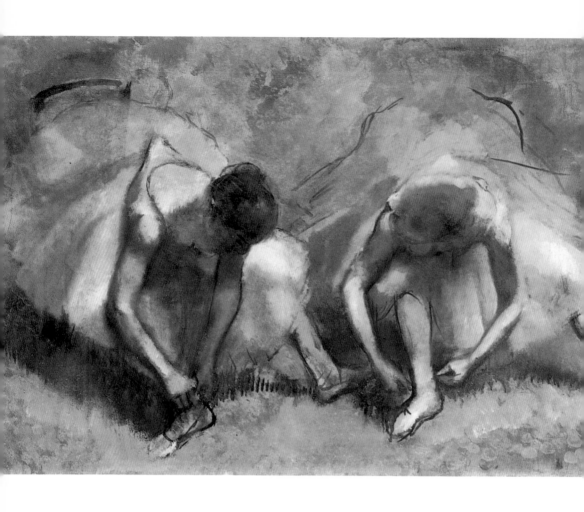

Wide-Screen Choreography

The collection of the Cleveland Museum of Art includes *Frieze of Dancers* (illus. above), a painting once owned by the German artist Max Liebermann, who admired Degas to the extent of publishing a booklet about him, in 1899, and buying a number of his works. The four dancers, bending forward to fasten their slippers, are arranged in an elongated decorative pattern. Their arms and legs describe a flowing, rhythmical movement that continues through

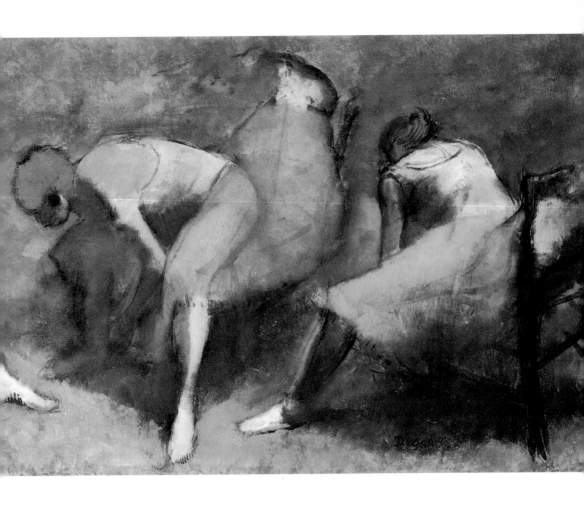

Frieze of Dancers,
1893–95

the shoulders, backs, and heads until it is interrupted by the chair-back on the right. The colors have an equal lightness and delicacy: one notes, in particular, the exquisite contrast between the bluish-green swirl of the costumes and the four golden-red highlights in front of the warm yellow and brown of the background. But perhaps the most remarkable thing about the picture is its "wide-screen" format (27 ½ by 79 inches), which is untypical of its time.

53

From the late 1870s on, Degas produced about forty of these ballet friezes (together with a number of equestrian pictures that have the same elongated proportions), although the dimensions, averaging around 18 by 31 inches, are considerably smaller than those of the Cleveland painting. The conception of the works may have been influenced by the decorative friezes found in many public buildings and private houses of this period. However, it is uncertain whether Degas ever actually received a commission of this kind, and one can safely assume that the main factor in his decision to use the format was its obvious suitedness to his "analytical" technique of repeating the same figure in different views and presenting the results in a carefully choreographed tableau. The Cleveland frieze, a relatively late work dating from 1895, is an excellent example of this approach, uniting cinematic and ornamental qualities with remarkable deftness and economy. Degas himself sums up his view of the relationship between pattern and ground as follows: "Ornament is the interval between one thing and an-

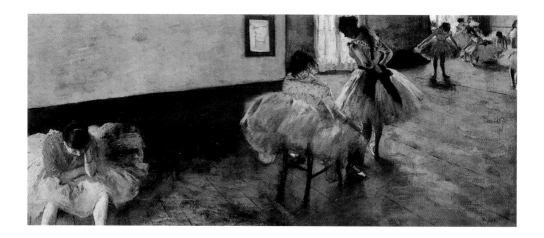

other. One fills in this interval with a relationship between the two things, and *there* is the source of ornament."[16] George Shackleford, who has investigated these works in detail, notes: "in the logic of Degas' argument ... it is not necessary... to fill the supposed interval with a physical object or design: the mind bridges the gap

The Dance Lesson, ca. 1879

Study of Dancers, ca. 1879

between the figures, thus understanding the ornamental unity of the composition."[17]

All the ballet friezes depict rehearsals or lessons. The earlier works of this type are far less stylized than the Cleveland example. In *The Dance Lesson* (ca. 1879), which is probably the first of the frieze compositions, the grouping of the figures is complex but appears comparatively loose and spontaneous (illus. opposite). The long chain of dancers extends all the way from the single

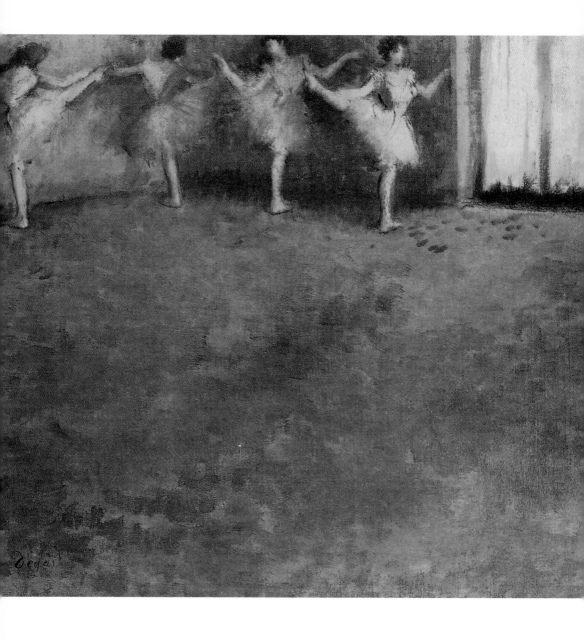

Before the Ballet, 1890–92

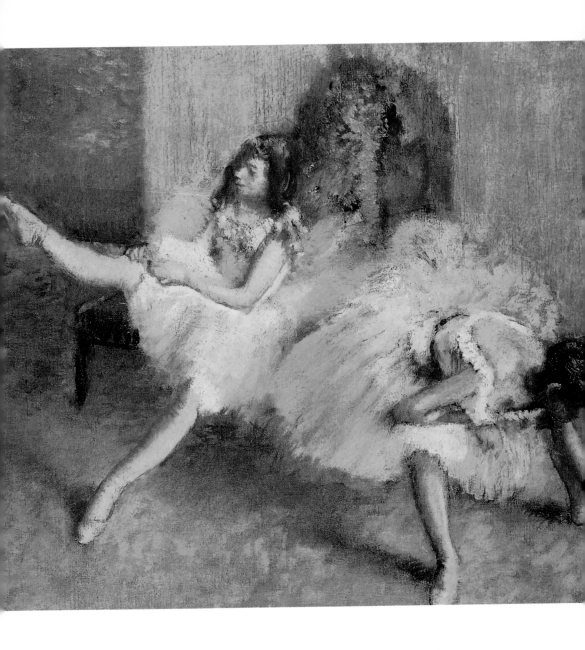

figure in the left foreground to the group far off in the back-
ground at the right. Degas creates an "unreal" spatial effect by the
extreme diminution of the figures at the back and by leaving the
wall on the left almost blank. The sense of oddness is heightened
by the sloping appearance of the floor and the oblique angle of the
light from the French windows. Yet this painting, too, contains a

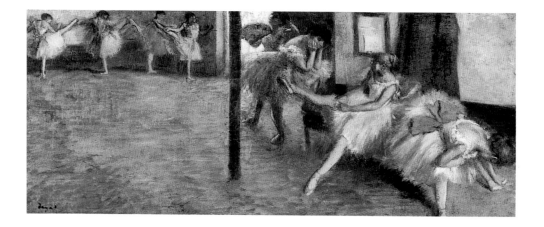

Ballet Rehearsal, ca. 1885

kind of ornamental pattern, formed by the similarities and oppo-
sitions between the poses in which the dancers are captured.

Several of the preparatory sketches for the figures in this pic-
ture have been preserved. In the most attractive example, the
drawing of the central figure is heightened with touches of brown
and olive chalk (illus. p. 55). It is also interesting to find that
the figure below has "loaned" her skirt, draped over a chair, to her
counterpart in the painting, which is dominated by the image of
billowing tutus.

A quite different ornamental pattern, based on the raylike
appearance of the ballerinas' limbs, is found in *Ballet Rehearsal*
(illus. above) and two very similar compositions painted at

around the same time. The outstretched arms and legs appear to quiver like rapiers. This particularly applies to the four dancers practicing the *grand battement* at the barre on the left, but the seated girl pulling up her stocking in the group on the right is also tensing her legs and pointing her feet, as if even this incidental action—a minor adjustment of the clothing—called for absolute precision. One notices that the axis of the picture is the pillar, positioned slightly off-center, which upsets the perspective and proportions in a similar way to the mirror-like contrast of the poses in *The Dance Lesson*. The sense of unreality is intensified by the colors—green, blue, and white—whose coldness and flickering texture convey a vaguely underwater feeling.

Dancer Adjusting Her Tights, ca. 1880

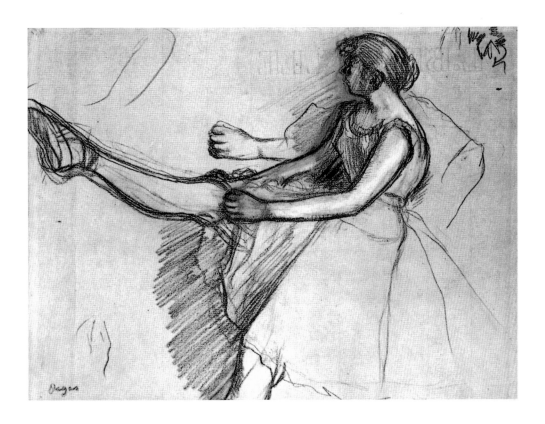

Dancers, 1900–10

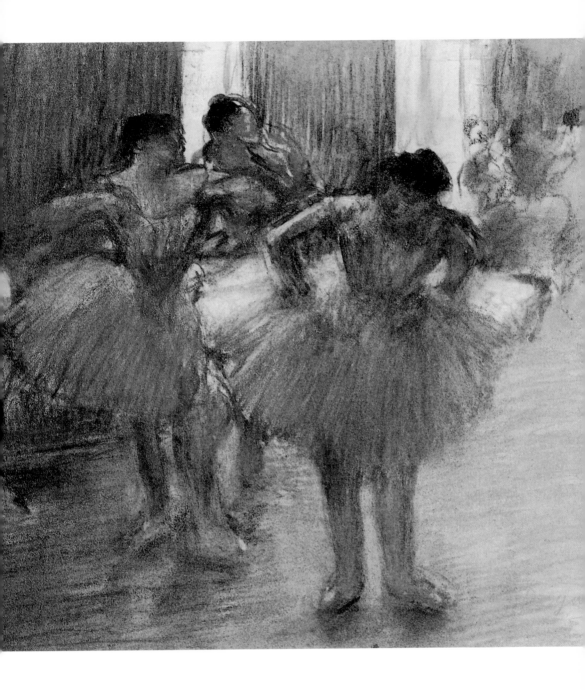

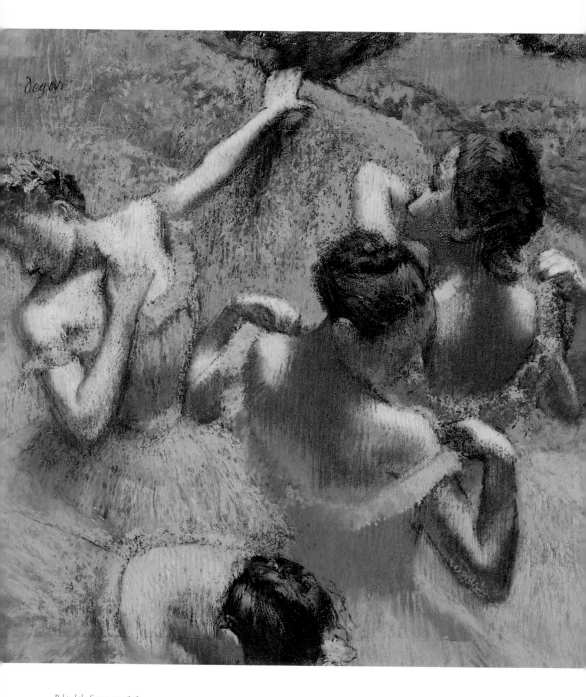

Behind the Scenes, ca. 1898

Painting and Photography

Degas never entirely abandoned the subject of ballet; he returned to it again several times and, beginning in 1895, he produced a series of pictures that addressed the familiar motifs in a new way. In most of these later works, he depicts three or four dancers in close-up, omitting the legs and concentrating instead on the movements of the arms and upper body. The incidental details of the setting recede into the background, and the dancers are rendered completely anonymous. In the previous ballet pictures, they had already been portrayed as highly artificial creatures but, at the moment of exhaustion, the mask was lifted to reveal a specific individual identity. Here, in the works of the 1890s, the faces are blurred to the point of becoming interchangeable. All that remains is form, texture, and the relationship of figure and ground,

Dancer, 1895–1900

Dancers, 1899

63

expressed through the medium of pastel, a technique that combines painting with drawing and articulates contour through color. In Degas' own phrase: "I am a colorist with line."[18]

As in the contemporaneous *Frieze of Dancers*, the three or four dancers often appear to be based on a single figure, depicted in different phases of a specific movement. This tendency is even more obvious in a series of oil and pastel works that resemble a slow-motion photograph of three or four figures carrying out the same action. The first image, of two arms—the one bent, the other outstretched or raised to the head—is followed by two depictions that show a figure solicitously adjusting each of her shoulder straps; in the fourth and final phase, the hands seem to be brought back together. This device of developing a movement from a single body is most clearly exemplified by *Dancers*, a pastel in a French private collection (illus. p. 63), and is employed with particularly dramatic impact in the Moscow pastel *Behind the Scenes* (illus. p. 62). The positions of the figures in the latter correspond closely to the movements of a dancer in a series of three photographic negatives that were found among Degas' papers after his death. These pictures were probably taken by the artist himself, who was keenly interested in photography at the time and frequently asked his friends and studio models to pose for the camera; the photographs were carefully stage-managed, using theatrical lighting effects.

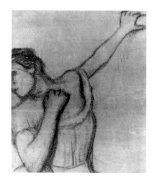

Study of a Dancer, ca. 1898

The multiple replication of a single figure is a logical adjunct of the shift toward abstraction that characterizes Degas' late ballet pictures and, indeed, his late work as a whole. His interest in movement becomes increasingly focused on a single aspect, the *ports de bras*, forming ornamental patterns that are composed either of sinuous arabesques or—in some cases, where the arms and legs of two resting dancers are combined into a composite image—of lozenge-like geometric shapes. "The dancers ... have become the substance of the picture itself. Their movements are the movement of the picture.... Now the body is its own music, the picture its own body."[19]

Formal abstraction also leads to the liberation of color. Degas himself spoke of an "orgy of color," and his pastels became ever more powerful and vibrant; he handled the material like paint,

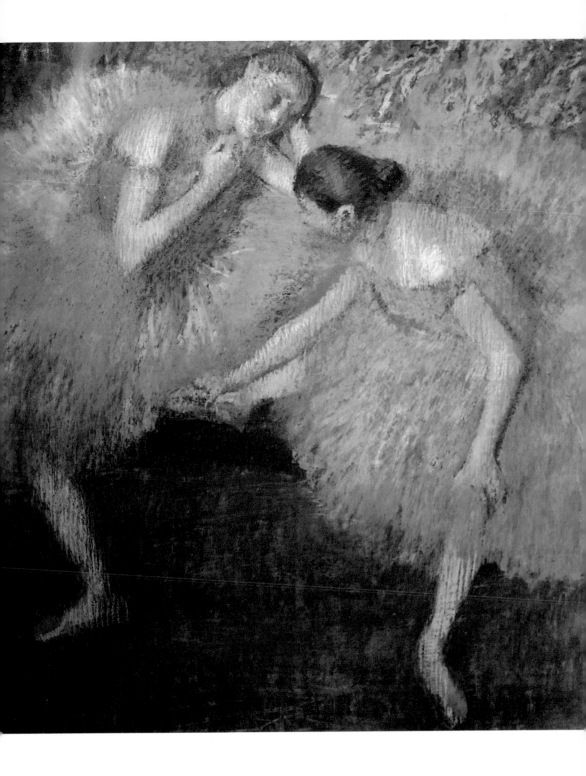

Two Dancers, ca. 1895

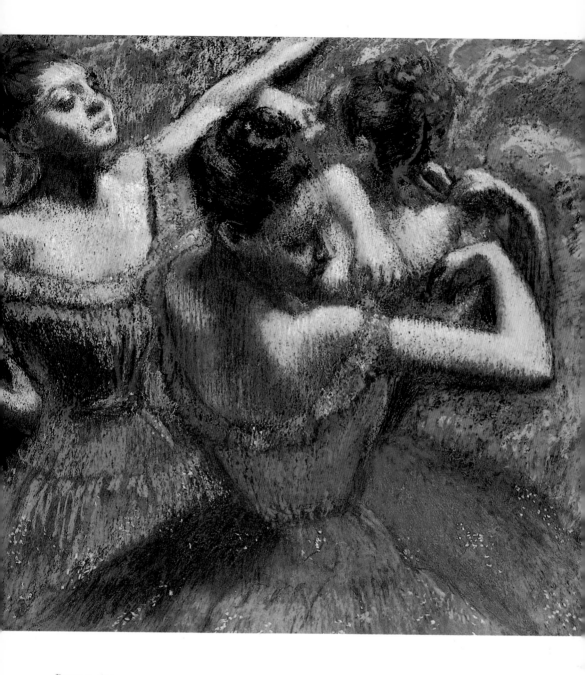

Dancers, ca. 1899

using his fingers as a brush to create *sfumato* effects, and building up heavy layers of impasto. From colors of varying warmth and coldness, from lines thick and thin, from hatchings and complex shadings, he wove a richly textured and chromatically intriguing surface like one of the oriental rugs of which he was notably fond, just as he loved the *Tales of 1001 Nights*. The exceptionally fine *Behind the Scenes* poses the question of how such a dense texture can seem so transparent. Although the dominant color is a powerful, radiant blue, it is shot through with touches of green and orange; the backs, the shoulders, the necks and faces are caught up in a scintillating play of light and shade. In *Dancers* (illus. opposite), in the Toledo Museum of Art, the harmonies of blue, violet, and scarlet are subtly varied with hints of ocher and green. And in the Princeton *Dancers* (illus. p. 68), the manifestly artificial colors display an almost unbelievable richness of nuance, based on the layering of cool and warm tones. The green and blue landscape of the backdrop is flecked with pink, violet, and orange, and the coral-pink costume of the figure seen from the rear is varied with stipplings of orange and green. Her skin is dusted with green and pinkish violet; her hair is tinted a deep orange-red. The figure next to her supplies a series of blue contrasts. Carefully balancing light with shade and establishing a relationship of perfect unity between figure and ground, Degas also elides the distinction between "noble" and "ignoble" gestures—with her left hand, the dorsal figure is striking a conventional pose of despair, echoed by the tragic expression of the woman on her right, but at the same time, she is using her right hand to scratch her back, in a manner that requires a measure of gymnastic skill. The ballet "girls" have come of age, but this makes it all the more necessary for the artist to include his favorite ironic motif, in order to ward off any risk of excessive pathos.

Some years later, Degas drew a series of pastels of Russian dancers, characterized by bold contours and thick, heavy shading, and set in a landscape that appears positively naturalistic, with "real" grass and trees and houses, instead of displaying the artificiality of a stage set (illus. p. 69). These works probably date from 1899, which is too early for them to have been influenced by Diaghilev's Ballets Russes—Degas certainly saw the company's debut at the

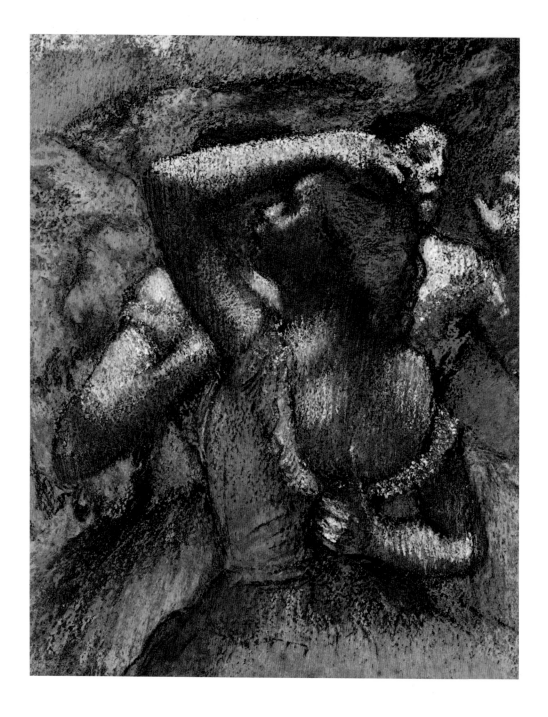

Dancers, ca. 1899

Théâtre du Châtelet in 1909, and may even have made some drawings of the performance, but there are no records to this effect. The drawings from the turn of the century were probably inspired by operas that included Russian folk-dance sequences. Arranged in groups of three, the ballerinas are shown stamping and high-kicking around the stage, with hands on hips or arms linked behind their heads; their brilliantly colored skirts and aprons are offset by white blouses with billowing sleeves, while the red of their Cossack boots is echoed by the flowers and ornaments in their hair. These are the final attempts of an artist whose sight is failing—and who can no longer rely on the eye to guide the hand—to evoke the dynamic spirit and the excitement of dance. In a letter to the sculptor Paul-Albert Bartholomé, Degas wistfully notes, with reference to his declining powers: "I speak about the past, because, excepting the heart, it seems to me that everything is getting older in me proportionally. And even the heart has something artificial about it. The dancers have sewn it up in a sack of pink satin, a little bit worn, like their dancing slippers."[20]

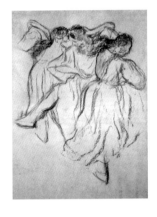

Three Russian Dancers,
1900–05

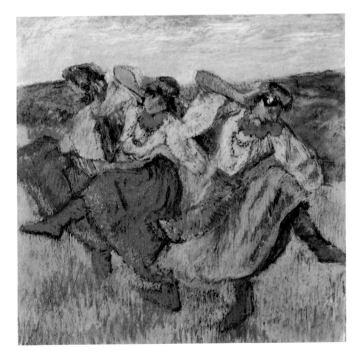

Russian Dancers,
ca. 1899

Cherchez la femme?

From 1877 on, the parade of dancers was accompanied and at times even replaced by an equally endless series of women depicted bathing or at their toilette. Together with the ballerinas, these nude figures dominated Degas' late work. Although he was an obsessive painter of women, Degas had a well-documented reputation for rampant misogyny. A number of his female portraits might seem to contradict this: one thinks, for example, of the depiction of the actress Joséphine Gaujelin, capricious but painfully vulnerable; of Mary Cassatt, Degas' robust and determinedly individual American colleague (illus. p. 117); of the pensive woman with the chrysanthemums, the pert *café-concert* singer (illus. right), or the laundress with the wide-eyed, childlike stare. All these figures are portrayed with such a profound sense of individual character, and such a clearly displayed understanding of sadness and loneliness, that one sometimes finds it difficult to credit the many contemporary accounts of his disdainful attitudes to women. But the reports exist, and the evidence appears overwhelming.

Certainly, Degas' personal relationships with women were fraught with difficulties. An inveterate loner, he fought shy of deeper involvements, and never married, although this may have had more to do with a fear of rejection than with an actual distaste for female company. His avoidance of matrimony may also have been influenced by his financial situation: after his father's death, he was obliged to continue supporting his brother, and was no longer in a position to make a proper bourgeois marriage.

Degas' series of forty brothel monotypes (illus. p. 47) inevitably gave sustenance to the myth of the bachelor-voyeur that was already circulating among critics and colleagues envious of his success. Yet prostitution was a popular subject of the day, addressed by writers such as Huysmans, Maupassant, and Zola, and by a whole range of visual artists who catered quite shamelessly to the appetites of their prurient clientele. Degas' pictures were quite different. With their restrained tone and occasional hints of irony, his depictions of the world of the *maisons closes* are probably more

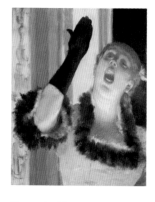

Singer with a Glove,
ca. 1878

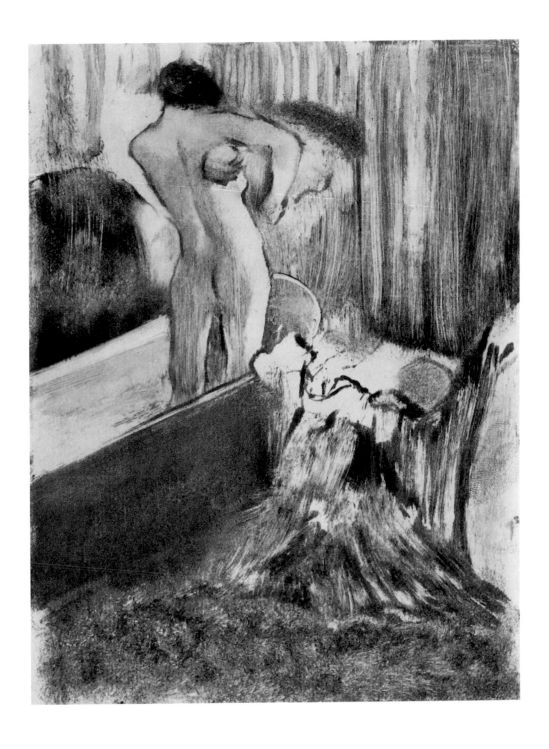

The Bath, ca. 1880

truthful, more genuine and less overtly titillating, than the equivalent works of any other artist. Picasso declared that they were Degas' real masterpieces, and was eager to collect as many of the prints as he could find.

To the puritans and vilifiers, it was obvious that all Degas' female nudes must be prostitutes, or at least women of extremely loose morals. But most of his "bather" images show the figure in dorsal view, and one wonders what led the critics to assume that the back in question belonged to a whore. In some of the later depictions, the back is tensely arched, almost as if an electric current is being passed through the body, but the source of this effect—stirrings of lust, a stomach pain, or simply problems in maneuvering the bath towel—is scarcely confined to a specific social class. Certainly, the pose of the plump figure in *The Morning Bath* (illus. p. 96) does not suggest that the subject received her training in etiquette from a governess, yet a number of the women in other examples of the genre are attended by aproned maids who would look quite out of place in a brothel.

Whole cartloads of fuel were added to this particular fire by the Irish writer and critic George Moore, who reported the artist's description of woman, in his pictures, as "the human animal taking care of its body," adding that the bathers were depicted "as if you looked through a keyhole."[21] A keyhole? The image seemed to confirm, once and for all, the notion of Degas as a voyeur, and it has often been quoted since, recently by feminists and gender theorists seeking ammunition for their views.

But in his obsession with the body, Degas said an awful lot of things, which cannot always be taken at face value. For example: "A cantering horse has more grace than a woman walking." Or, looking at a piece of granite that he had picked up in the street: "What a line, as beautiful as a shoulder!" Much less attention has been paid to statements of far greater significance, such as "The dancer is only a pretext for drawing"[22]—a dictum that applies equally to the horses, the bathers, and even the landscapes. Cherchez la femme? Trouvez l'art!

Woman before the Mirror, ca. 1877

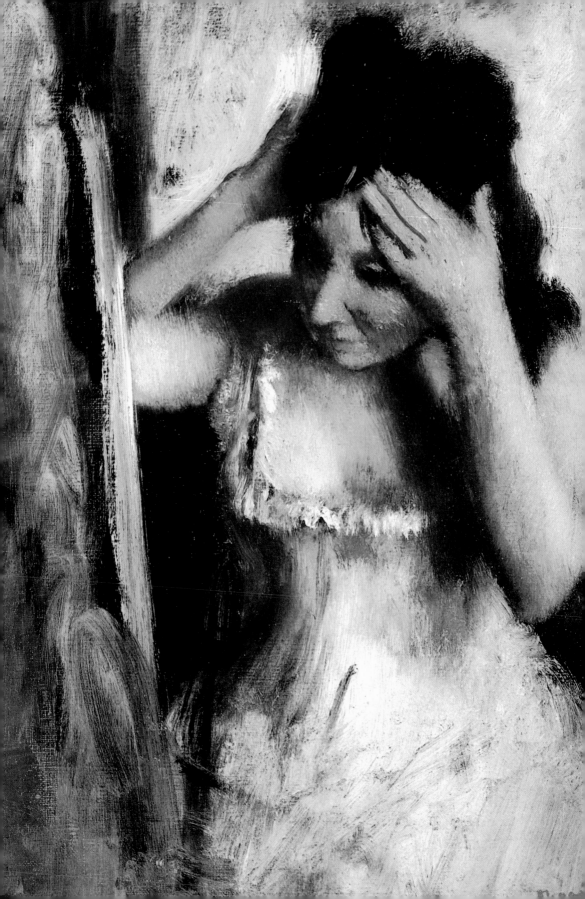

The Expressionless Nude

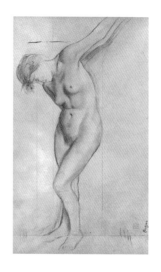

Degas' nudes are anchored firmly in the tradition of Watteau, Boucher, Fragonard, and Ingres. This is quite clear from his early history painting *Scene of War in the Middle Ages* (illus. below) and its preceding series of exquisite sketches of women, naked and exposed to the violence of their male raptors (illus. right).

Traditional nude figures are rarely naked in the full sense; instead, they come heavily clothed in mythology and history, in the poetry and symbolism of the exotic. And above all, they are surrounded by a nimbus of cultic adoration, based on the competing notions of woman as a source of comforting maternal warmth, or as the cold-blooded embodiment of cruel nature. These two views are ideally exemplified by Ingres' *Venus Anadyomene* and *Grande Odalisque*: the one an entirely "natural" specimen of burgeoning womanhood, the other a sophisticated whore, elegantly groomed and pencil-slim, casting a contemptuous glance over her shoulder

Standing Nude Woman: Study for "Scene of War in the Middle Ages," 1863–65

Scene of War in the Middle Ages, 1863–65

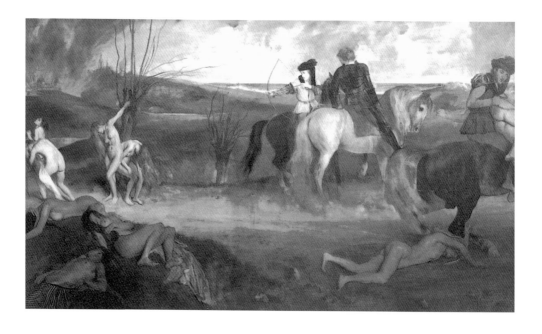

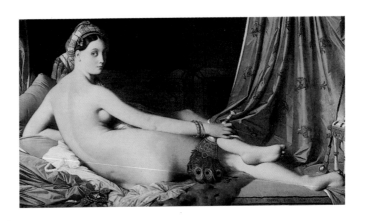

Jean-Auguste-Dominique Ingres, *Grande Odalisque*, 1814

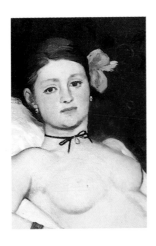

Edouard Manet, *Olympia*, 1863; detail

(illus. above). With the emergence of the nineteenth-century conflict between classical and "modern" conceptions of form, a new set of inhibitions had grown up around the depiction of the naked body. Both types of nudity—the natural and the eminently artificial—were a source of continual unease and even outrage.[23] In Paris, admittedly, the annual Salon was full of metaphorically clothed nudes—a tendency mocked by a Daumier cartoon of 1865, in which two staunchly respectable ladies are seen remarking: "All these goddesses again this year.... Venuses, nothing but Venuses.... as if such women really existed." But the blatant sexuality of Manet's *Déjeuner sur l'herbe* (1863) and *Olympia* (1865) caused two major scandals in quick succession. Almost certainly, it was the gaze that sparked the commotion. The naked woman enjoying a picnic with two fully dressed men fixes the viewer with a steady, challenging stare, and Olympia wears a look of unbridled boldness (illus. left). As sisters of Goya's *Naked Maja* and Ingres' *Grande Odalisque*, they combine sexual promise with an air of haughty disdain that at once denies and reinforces their allure. This is the specific mixture of forwardness and reserve that makes the male viewer's blood run faster.

Alluding to the three-way relationship of complicity between artist, model, and viewer, Degas commented: "Hitherto the nude has always been represented in poses which presuppose an audience."[24] While disguising nudity in terms of mythology, religion, or nature, earlier painters had been careful to offer the viewer a

75

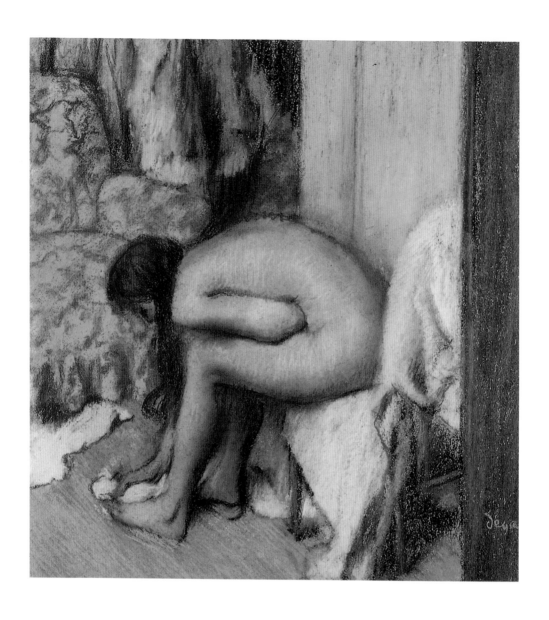

way of entering the picture and joining the conspiracy. And even
the boldness of Goya and Ingres in showing that the Majas and
Odalisques are professional courtesans—and that, in the words
of one critic, "the painter knows his way around the woman's bed-
room"[25]—strikes a discreet pact with the beholder, who is invited

Nude Woman Drying Her Foot,
1885–86

76

to appreciate nudity as an instrument, one of the technical devices that woman uses to pursue her sexual and commercial ends.

Degas' female nudes are different. The titles of these works — *Bather, The Tub, Woman at Her Toilette*, and so forth — should not be taken too literally. Most of the women are not in fact directly engaged in washing themselves, and the setting is hardly ever a bathroom, while the expression "toilette" has misleading associations of mirrors, hairpins, and makeup. Perhaps, after all, the word "boudoir," suggesting a particular kind of privacy and intimacy, may offer the most appropriate way of describing the scene, although the amorous connotations of the term have to be stripped away — for the atmosphere of these pictures is decidedly non-amorous.

Woman in a Tub, 1884

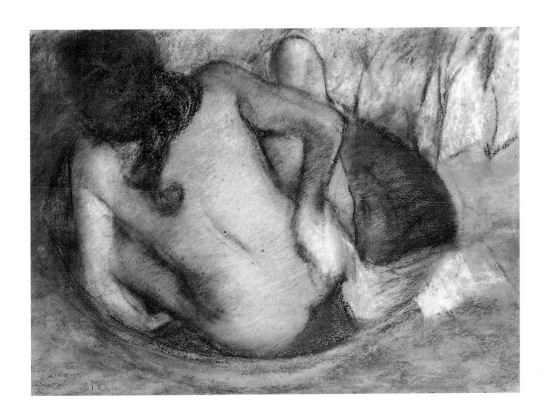

Many of the women are toweling themselves dry, a mundane activity that is nevertheless pursued with a degree of care and single-minded concentration that lends it an almost ritual quality. The viewer sees little more than the figure's back; the face, if visible at all, is seen in profile only, and the gaze is directed elsewhere. In one picture after another, we find an anonymous and expressionless nudity, chastely self-absorbed and oblivious to the spectator. If one of these women were to turn and look at the viewer directly, the entire situation would immediately be transformed—no matter whether the facial expression were innocent or knowing, inviting or filled with hatred, the scene would be redefined as one of ambiguity or even outright lewdness. But instead of dramatizing the figure's nakedness, Degas discreetly allows her to carry on with her essentially private activities, unobserved and therefore uninhibited. Nevertheless, as it is in the nature of any depiction to open up the imaginary fourth wall, the absence of an observer is inevitably a fiction, encapsulated by the painter himself in the famous "keyhole" metaphor that has attracted so much hostile attention.

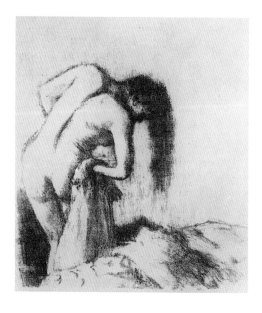

After the Bath III,
1891–92

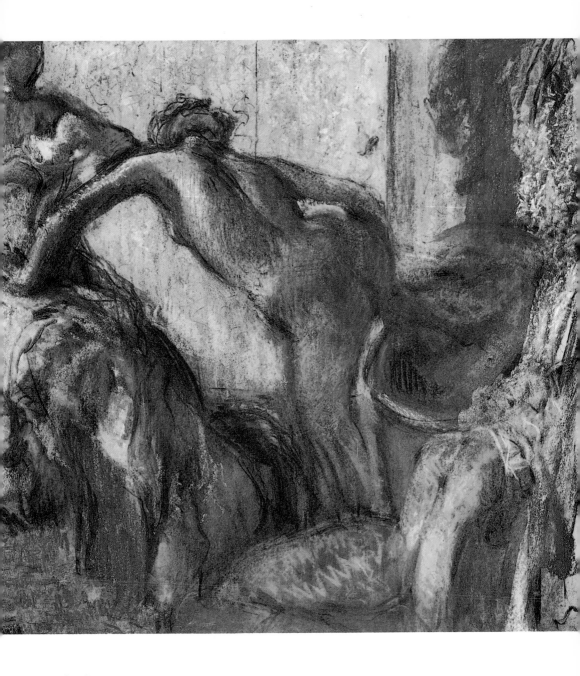

After the Bath, 1895–1900

Whores and Housewives

Degas reveals very little of the interiors between the remaining three walls. The images are severely cropped, leaving only details of the surroundings—an alcove, a chair, sometimes a table, carpets, curtains, sheets, and towels. A dominant feature, often standing right in the center, is the bathtub, alternately tall-sided and oval or round and low-edged; but sometimes the washing facilities

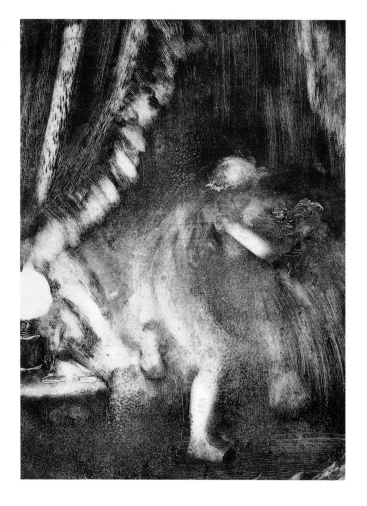

Retiring, ca. 1885

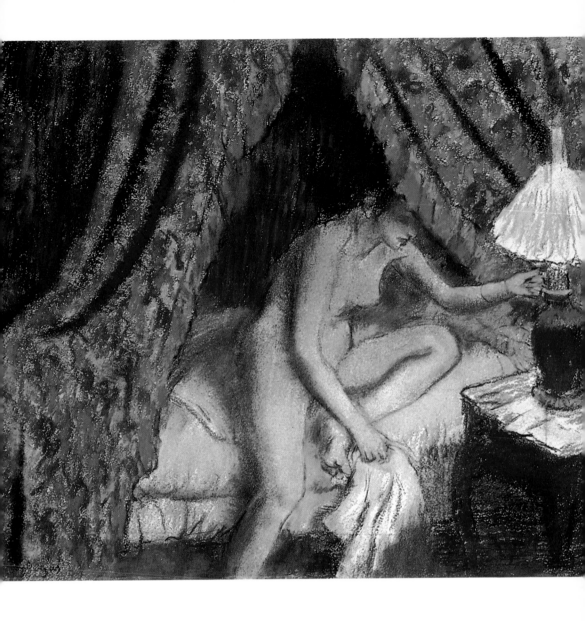

Retiring, ca. 1883

are limited to a mere bowl of water. Nearly all the pictures are set in a chamber that combines the functions of bedroom and dressing room. Bathrooms as such were still a rarity in nineteenth-century Paris; they were almost entirely confined to the houses of the very rich, and were seldom found in ordinary middle-class dwellings. Few people bathed more than once a month, and for women, washing was even viewed as unhealthy, partly on moral grounds, but partly also because the quality of the water in big cities such as Paris left much to be desired.

A recent study, situating the art of Degas in its social context, emphasizes that only prostitutes bathed regularly and thoroughly, because they were required to do so by the regulating authority. Thus the combination of women with bathtubs became "the centerpiece of a contemporary pornographic formula."[26] This can scarcely count as hard evidence that Degas' bathers were prostitutes, but it does go some way toward explaining the vehemence of the attacks on Degas by contemporaries such as the critic Félix Fénéon, an admirer of the artist who nevertheless described the nudes in terms of excited horror: "Crouching, gourd-like women fill the bathtubs.... One, with her chin on her breast, is scratching the nape of her neck; another, her arm stuck behind her back, is twisting round in a half-circle to rub her behind with a dripping sponge.... A pair of forearms reveals luscious, pear-shaped breasts, diving vertically between the legs to moisten a towel in the tub of water where the feet are soaking.... Another woman seen from the front, on her knees, is drying herself, with her thighs wide open and her head sunk over the loose flesh of her torso. And the scene is set in a disreputable furnished room, a mean and vile retreat, where these heavily patinated bodies, ruined by debauchery, childbirth, and disease, are being scraped and stretched."[27]

One could quote any number of similarly lurid and misguided descriptions by Degas' contemporaries. Today's interpreters dig somewhat deeper in their search for pornographic implications. Here, for example, is a passage, dealing with *Woman Leaving Her Bath* (illus. p. 85), whose author also proceeds on the assumption that the setting is the antechamber of a prostitute's bedroom: "The erotic tension resulting from the ambiguities ... is amplified by the inclusion of the empty chair. The chair signifies a watching

Bather Drying Her Legs,
ca. 1900

Seated Woman Pulling
Up Her Stocking, ca. 1885

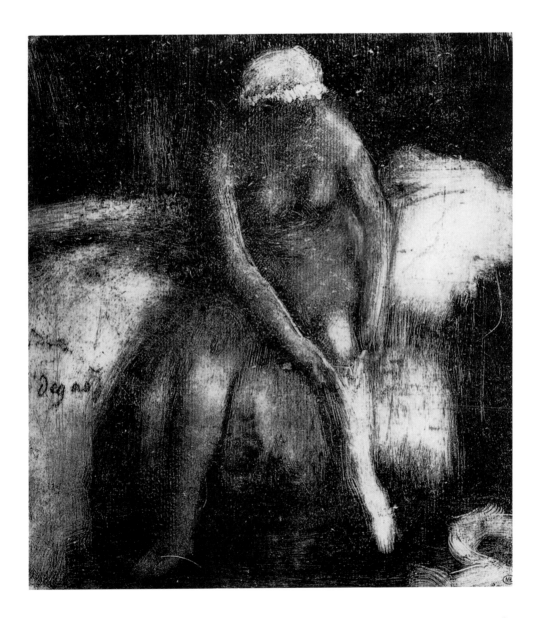

admirer while simultaneously, and in spite of the apparent self-absorption of the female figures, the open door solicits the spectator's gaze; is the empty chair that of the spectator, or of a client 'within' the room, hidden from view? Unobserved on the threshold, the male spectator blocks the exit to this claustrophobic room, his presence and his gaze—a function of the artist's—controlling the figures contained within. The open door, then, heightens the excitement both of discovery by another man, and of anticipated gratification. As such it helps inscribe an idea of the passage of time, of a past, present and future. But paradoxically, inevitably, the spectator's actual position remains that of an outsider; he is condemned forever to anticipate—which is the form of gratification sought by the voyeur. He might only long for and live out in fantasy a share in the intimacy portrayed between the two women—the cosy physicality his bourgeois masculinity denied him. Such intimacy represented for the bourgeois a stimulus of both desire and revulsion: a polarity constituted in Degas' work—and replicated in the act of consuming it."[28]

Clever though it may be, does this heady mixture of psychoanalytic and sociological reasoning really have much to do with Degas' art? For example, the claim that the empty chair is a coded image, implying the male presence, disregards the possibility that the chair, draped with a cloth, may simply be a gesture of formal exuberance, a straightforward invitation to revel in the pleasures of form and color. In his brothel monotypes, Degas did indeed use a number of conventional voyeuristic metaphors, such as the bunch of flowers for the female sexual organs, or the champagne bottle and the walking stick for the phallus. But this is done in an unmistakably ironic spirit. Some of the monotypes made immediately after the brothel series even present the bathers in poses that cater quite unequivocally to a specifically male gaze. These, however, are exceptions, surprising by virtue of their rarity in an oeuvre encompassing such a vast number of representations of the female body. Degas' personal attitudes to women may have been typical of his time, but as an artist, his approach was very different: in general, his depictions of women are remarkable for their matter-of-factness and lack of innuendo.

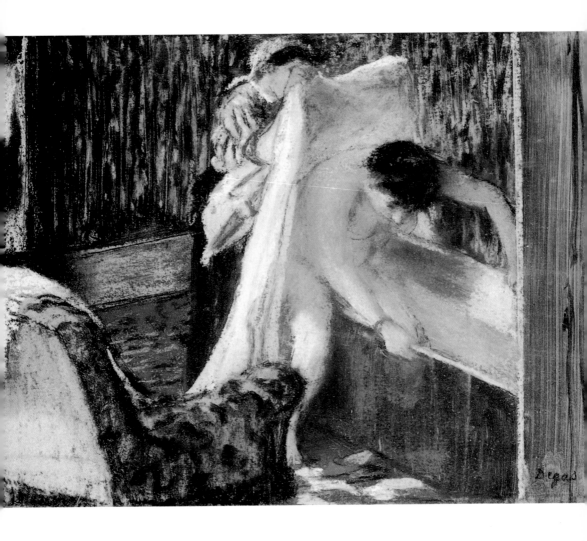

Woman Leaving Her Bath,
1876–77

So who in fact are the women in the bather pictures? Are they whores or housewives? Using a modicum of imagination, it is possible to guess at the identity of some of the figures: a young lady of good breeding (illus. p. 99), a daughter of a middle-class family (pp. 94, 95), a shopkeeper (p. 96), or an obvious street-walker (p. 86). Essentially, however, the subjects are anonymous: they are neither characterized as individuals, nor are they clearly identified as social types. From the accounts of Degas' friends and associates, we know that he used specific models for these pictures, but we do not know exactly to what extent or for which

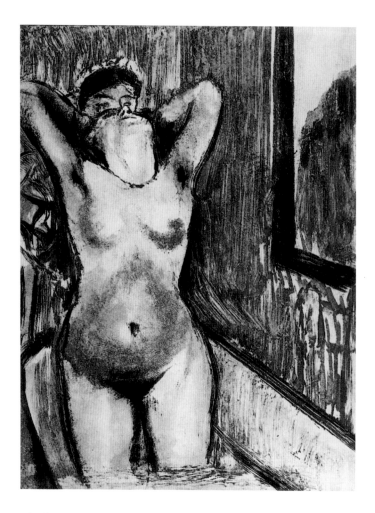

The Tub, ca. 1880

techniques. It is likely that he based many of the pictures on his large stock of previous drawings, and that in some cases he relied entirely on memory; he probably also made occasional use of photographs. The settings are heavily standardized, comprising a limited range of elements that may have been taken from a corner of his own studio.

But what was Degas seeking to convey, if he was interested neither in individuals nor in types? He was trying, it would seem, to speak of the female body as a faceless and timeless object, a pure gesture of the flesh.

Woman Bathing in a Shallow Tub, 1885

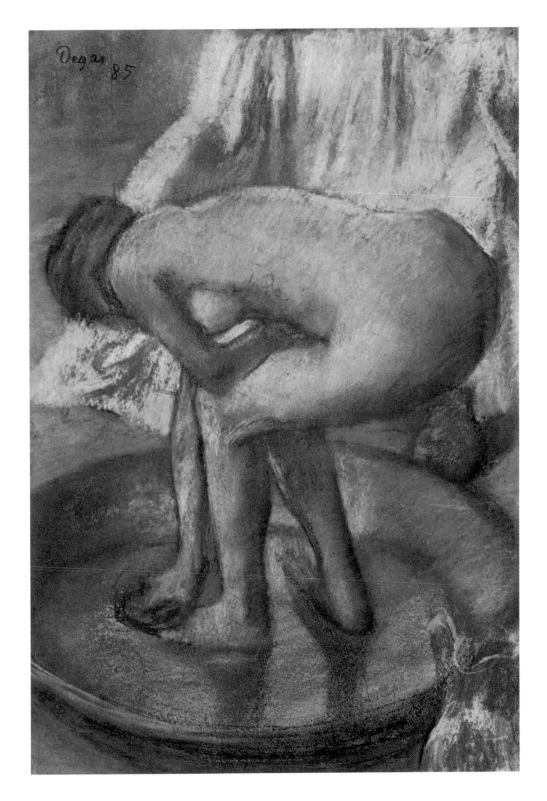

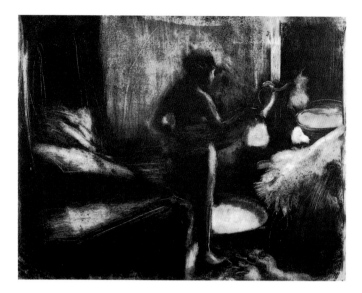

Twilight Figures

In this area, we find two separate stylistic currents: the restrained naturalism of the pastels and the astonishing "animal" abstractions of the monotypes. In view of their greater boldness, it may seem surprising that Degas embarked on the monotypes in 1877, whereas the first of the pastels—using larger formats than the works that preceded them—date from 1884. But this can be attributed to the artist's passion for experimentation, which could be indulged more freely in the medium of monotype. During his lifetime, these works were seen by only a few people, mainly connoisseur friends. Perhaps it was just as well that they were not revealed to the public until after his death: the feverishly eloquent strictures of Félix Fénéon, quoted above, give an indication of the hue and cry that would certainly have ensued if the secret had got out.

Nude Woman Combing Her Hair,
1879–83

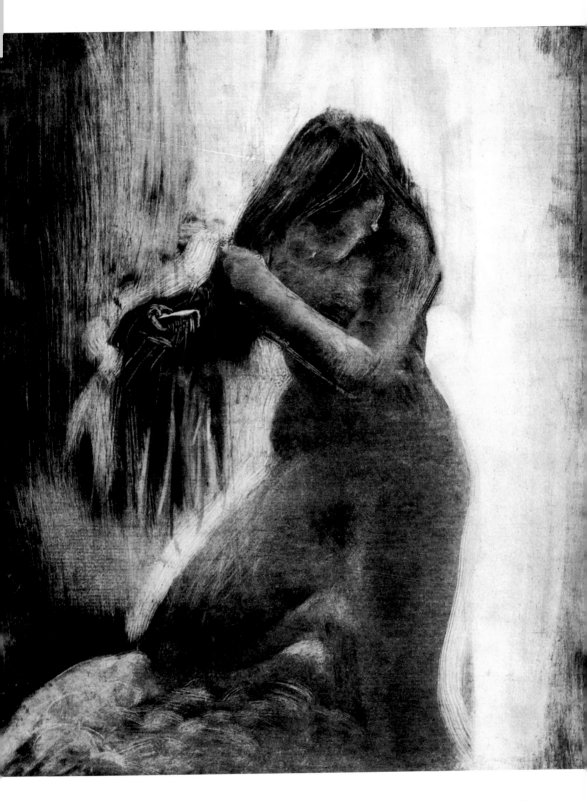

These pictures take us into a twilight realm where fragments of detail—the flesh, the drapery, and the gleaming edge of the zinc bathtub—loom out of dark depths of black and gray (illus. pp. 71, 80, 88–93). The light, dim yet glacial, reveals bodies that are unreal in their strangeness but also have a sharply aggressive animal presence. Some of the figures are seen in the bathtub, rubbing their feet or bending over the edge to reach for the towel; others are standing with their forearms immersed in a basin, reading a newspaper, sitting on the bed to pull on their stockings, combing their hair in front of a curtained window, or suspended in a state of dreamlike stupor. The bodies are neither exemplars of academic proportion, nor do they manifest the ugliness described by contemporary critics of Degas' art. They are certainly uneven: the hips are somewhat coarse, the breasts and bellies over-fleshed, the

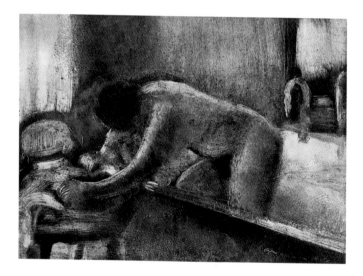

Woman Leaving Her Bath,
1879–83

hands and forearms thick and clumsy, like the paws of a large, ungainly animal. Their poses, too, are often graceless, as they stoop or recline; or lopsided, as they struggle to keep their balance while standing in the tub. Yet their relaxed, unselfconscious sensuality also gives them a raw, elemental power.

Woman Standing in Her Bath,
1879–83

90

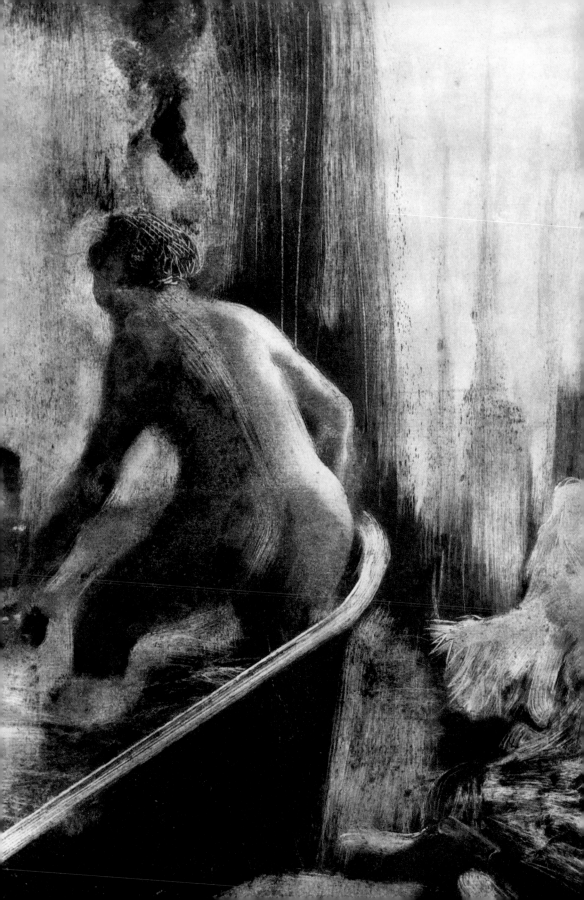

The light trickles and eddies around these figures, pausing at the belly, thighs, or shoulder, and briefly exploring the spine. It seethes in the bathtub, gives the lamp the appearance of alabaster, and transforms the edge of the newspaper into a glowing neon tube, suffusing the pictures with a ghostly luminescence that has no readily identifiable source.

Made by the "dark-field" process, in which the design is produced by removing ink from the plate, this series of monotypes is characterized by a remarkably subtle interplay of light and shade, combining broad, flat areas and sweeping contours with dabs and flecks of detail—clouds, spots, and squiggles, odd maculations and elements of *craquelure*—that serve to articulate the notions of carnality and materiality in a narrow and essentially fragmentary space. Despite its vastly reduced scale, the reproduction of *Torso of a Woman* on the facing page may provide at least some idea of the

Nude Woman Scratching Herself, 1879–83

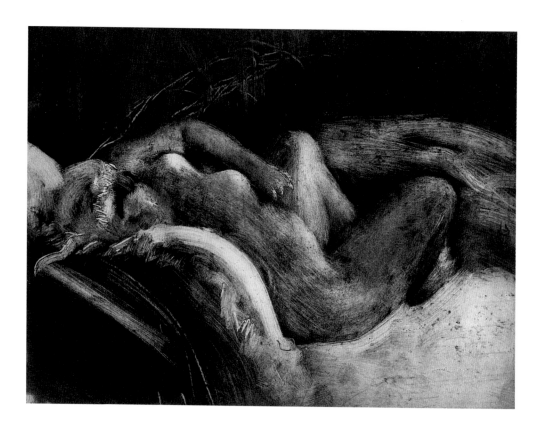

Torso of a Woman,
1889–90

combination of monumental outline and richly nuanced interior detail. The atmosphere of mystery in this crepuscular world is markedly influenced by the example of Rembrandt's much-admired "night" etchings, in which, as Otto Pächt remarks, "chiaroscuro is a normal aspect of visible reality, regardless of the lighting conditions that apply at a given moment."[29] In Degas' own era, only the drawings of Georges Seurat display a more finely woven tissue of light and dark. The shadowy appearance of the monotypes also makes one think of photographic negatives. Some of the scenes showing the various stages of rising and going to bed, or the depictions of figures getting out of the bath, could be assembled into sequences that would have an almost cinematic effect, like a silent film composed of a series of negative images.

Venus in the Bathtub

The robust creatures of this exclusively female realm are soon to emerge in a quite different guise, steeped in the cool colors of the early morning. Indeed, some of them take on a girlish fragility and delicacy that led George Moore, like many later critics, to describe them in terms of a modern Venus in her shell; one of their various poses (illus. below) recalls the antique *Crouching Venus* sculpture in the Louvre. For Degas, it was a simple matter to draw classical Dianas, Eves, and Bathshebas, but his aim was precisely not to reproduce academic paragons: instead, he sought to convey movement, to capture exactly the natural appearance of the human

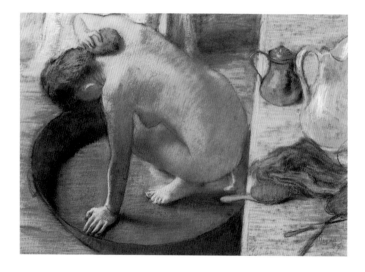

Woman Bathing in a Shallow Tub, 1886

body, right down to the twitching of individual muscles. This had nothing to do with "naturalism" in the accepted sense. In one study after another, Degas filtered and refined the gestures, distilling and redistilling the image to produce a pure, absolute essence—a process taken to extreme lengths in his later nudes. And the movements always had to be the most complex imag-

Woman Bathing in a Shallow Tub, 1885–86

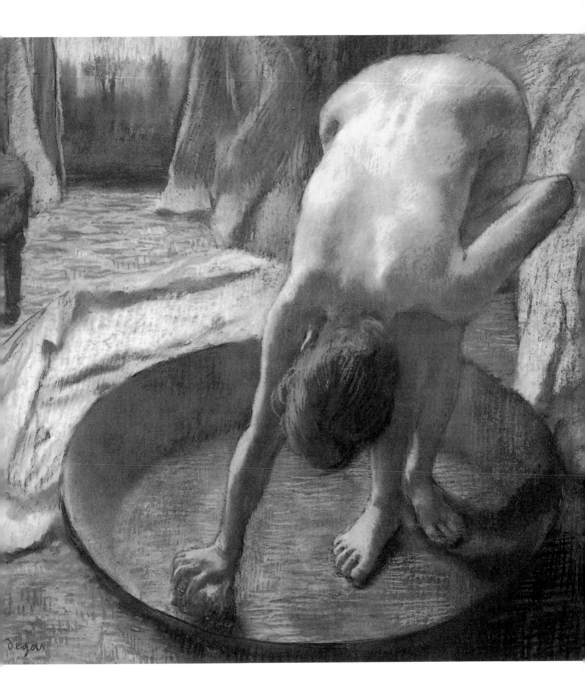

inable. The chestnut-haired figure resembling the Venus in the Louvre crouches in the low-sided tub, supporting herself with her left hand and lifting the sponge to her neck with her right; in a further variation on the same theme (in all, there are seven versions of this picture), she is shown bending forward, with her feet set slightly apart, and wetting the sponge in the shallow water with

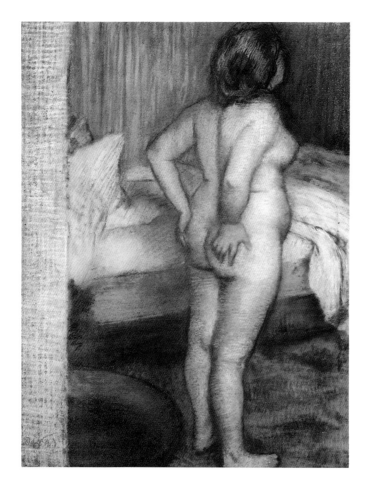

The Morning Bath, 1885–86

her right hand while steadying herself with her left hand on her thigh (illus. p. 95). In both images, the body is seen in full view, framed in the one case by billowing drapery, and offset in the other by the vertical line of the cupboard or dressing table, the

After the Bath, 1883–84

harshness of which is mitigated by the still-life arrangement on the surface—the two jugs, the wig, the curling tongs, and hairbrush—whose forms and colors are made to echo the beauty of the woman's body. The bluish morning light fills the chamber in a way that epitomizes Degas' art, playing an elaborate game with the shadows and especially showing off the back, shoulders, and arms. Here, the pastel lines are still fine and delicate: one's eye is attracted, in particular, by the green, yellow, and red threads of the rug, the streaks of blue, pink, and orange in the reflecting surface of the shallow water, and the dense white texture of the towel.

The slender figure in *The Morning Bath* (frontispiece) has echoes of Diana the huntress, caught between forest and stream, but at the same time she recalls the male nudes of Leonardo and Michelangelo. Her pose is graceful and elegant: with one foot already in the bathtub, and the other still on the floor, she is using her arms to maintain her balance. The wallpaper and curtains create the effect of a cool forest glade, whose light greens and blues are dappled with sunlight that also leaves its reflections on the most delicate areas of the woman's body, from the armpits down to the curve of the buttock. The large bed in the foreground has the piled-up appearance of a sand dune; it seems to distance the figure from the viewer and, through its color, it also usurps and assimilates the garment that she is casting off.

Not all the women in Degas' boudoir scenes are as delicate as this: the artist was also prepared to depict bodies that were far stouter and less obviously attractive, despite the comments of critics such as George Moore, who accused Degas of sensationalism, describing the figure in another *Morning Bath* (illus. opposite) as "a short-legged lump of human flesh" designed purely to provide modern art with "un frisson nouveau," just as Baudelaire had done for literature.[30] Moore also claimed that the woman, who, despite the subtitle later given the picture—*La Boulangère* (*The Baker's Wife*)—was the wife of a butcher, had appeared at Degas' studio with her husband, dressed in her Sunday best, and had been mortally disappointed to find that she was expected to pose in the nude. When the husband demurred, Degas managed to calm his fears by explaining that he himself had no particular interest in sex.

The accusations of cynicism were unfair: in fact, Degas gave the firm-fleshed figure in this work a particularly clear and pleasing set of contours, with a strongly emphasized dorsal line. The angular position of the arms is found in a number of later variants, just as the delineation of the body is anticipated by drawings and monotypes made some years previously. The hands are coarse and reddened. This may be one of Degas' rare allusions to a specific milieu—an impression reinforced by the cheapness of the wallpaper on the left and the claustrophobic stuffiness of the room. At all events, the body, which is still glowing with the heat of the bath, is surrounded by a combination of colors that has a cooling effect but still retains a modicum of warmth.

Talking to the writer Edmond de Goncourt, one of Degas' models described the artist as "a strange gentleman": during an entire four-hour sitting he had done nothing but comb her hair. Women dressing their hair was one of his favorite subjects, which he addressed in a whole series of lyrical paintings, pastels, and drawings, including the exquisite *Nude Woman Having Her Hair Combed* (illus. opposite). In this case, the self-appointed guardians of taste and morality had nothing to protest about. Sensuously self-absorbed, yet in a pose that remains entirely decorous, the sleek and well cared-for young woman sits on her divan, allowing herself to be groomed by the semi-visible maid, whose face is trimmed out of the picture so as to focus all attention on the main subject. The three-quarter view of the seated figure also has a certain comforting familiarity: the pose is clearly borrowed from Rembrandt's portrayal of Bathsheba at her toilette.

Nude Woman Having Her Hair Combed is a veritable celebration of the flesh. Sublimely contoured and shimmering like porcelain, the woman's body is ceremonially presented on the bathrobe, which spreads out over the divan like a train of precious ermine on a golden throne. The handling of the color is extraordinarily subtle. Flecks of blue light are visible on the surface of the bathrobe and the maid's apron; the olive green and gold of the curtain and the divan are enlivened by streaks of flaming red; the coral-pink threads in the maid's blouse are repeated in the turquoise rug; and the white skin has a faint greenish cast. Even the buttoned upholstery of the daybed is echoed in the bulges of the woman's ample

*Nude Woman Having
Her Hair Combed*, 1886–88

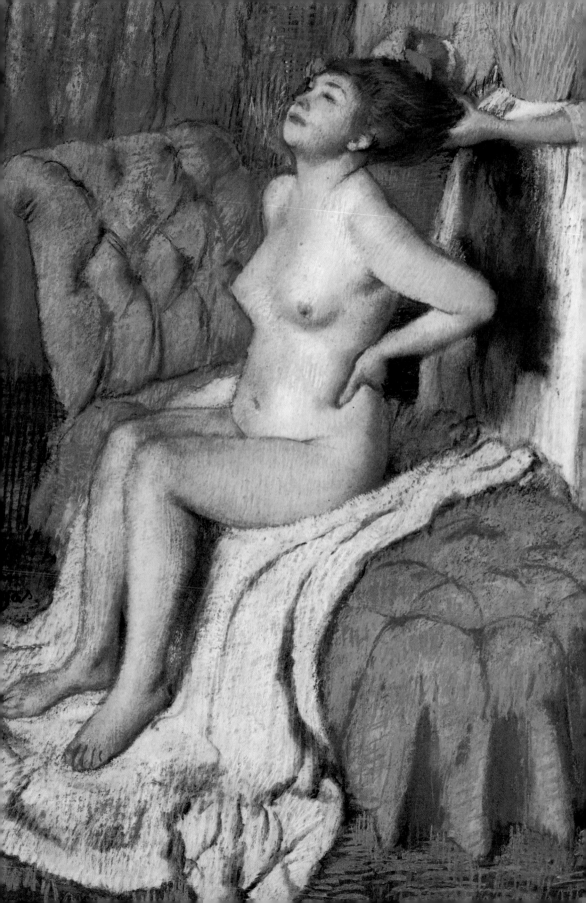

figure. Warm colors are overlaid with cold and vice versa; the zones of color are clearly demarcated, and the relationship between color and line is one of perfect harmony. The greenish tinting of the skin is exemplified even more clearly by the cello-like figure in *Nude Woman Combing Her Hair* (illus. opposite). This device—the use of green as a second flesh tone—was recommended to his pupils by Cennino Cennini. Nearly five centuries later, Degas took up the idea and employed it to remarkable effect.

How does a women dry her flank? Degas answers this question in a whole range of fascinating ways. The gestures involved, which are derived from Delacroix, are anticipated in Degas' history paintings, which contain a number of painfully contorted female figures with lowered heads and waving hair (illus. p. 74). Degas was never able to let an idea go: once it had taken hold, he pursued

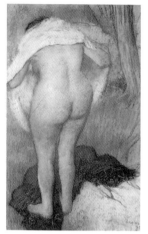

Nude Woman Drying Herself,
1885

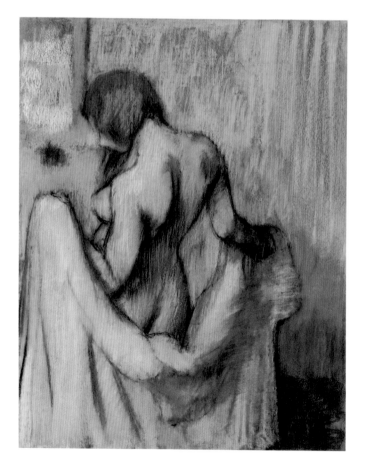

Woman with a Towel,
1898

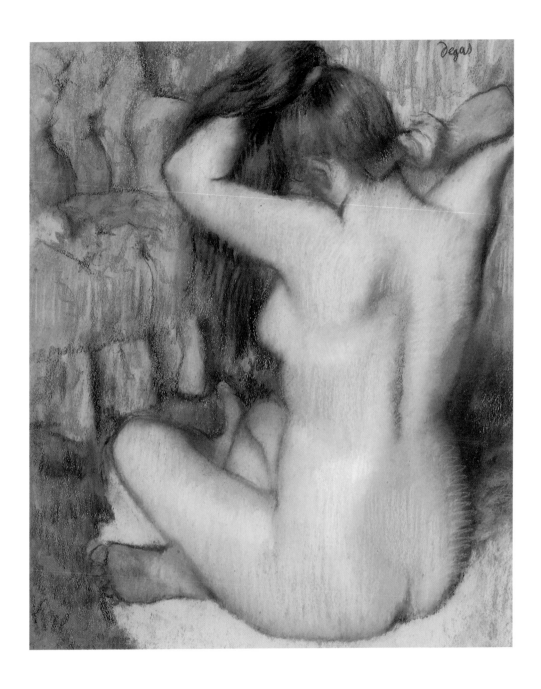

Nude Woman Combing Her Hair, 1886–88

it relentlessly. The image of the woman drying herself is reformulated in his drawings and lithographs, which depict the figure in dorsal view, focusing on the hips and the bath towel—the body is slightly inclined to one side, the mane of hair is parallel to the arm bent at the elbow, and also follows the visual rhythm of the towel. The size of the figure varies from one version to another, and the artist continues to experiment with the proportions, the angle of

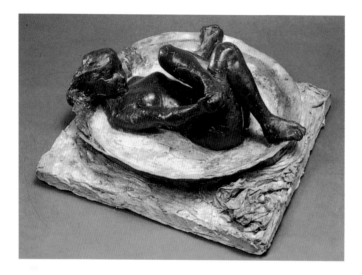

The Tub, 1888–89

the head, the height of the shoulders, the shadows around the spine, and the length of the hair. In particular, he exploits the possibilities of texture, refining and varying the line and shading, to modify the temperature of the bodies and create new spatial and atmospheric effects.

And when the water nymph takes on three-dimensional shape (illus. above), she makes herself as comfortable as if she were seated in an armchair, casually crossing her legs and forcing the beholder to confront her from above, in a way that sculpture had never demanded before. (In the wax original, the rosy-fleshed figure, clutching a real bath sponge in one hand, was shown reclining in a lead tub with "water" made of plaster.) In some examples, she really is sitting in an armchair, lazily stretching her limbs and holding out one leg for the maid to administer an after-bath

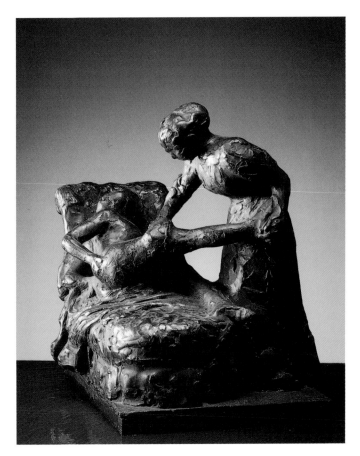

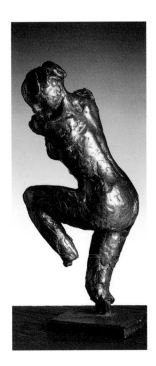

Woman Leaving Her Bath,
1895–1900

massage (illus. above). In others, she is stepping out of the tub, almost taking on the shape of a Daphne who is being transformed into a laurel tree (illus. left).

From about 1890 on, Degas' nudes became popular with collectors and began to exert considerable influence on other artists. Vincent van Gogh was greatly impressed by these works, and Paul Gauguin copied some of the poses for his depictions of Tahitian women. Henri de Toulouse-Lautrec, Georges Jeanniot, Charles Maurin, and Louis Legrand also took up Degas' ideas and adapted them in a variety of more or less original ways: the Paris art world even began to speak of "Degasism." However, the boldest and most innovative treatments of the female body were yet to come. The subject of the nude continued to dominate Degas' work for the remainder of his creative life, until the year 1908, when blindness finally condemned him to inactivity.

Explosions of Color

The lady pastelists of the eighteenth century would have collapsed with fright if they had been able to anticipate how the softness and delicacy of their colors would be supplanted by the chromatic frenzy of Degas, and how their decorously soulful flower pictures would be replaced by evocations of sheer naked flesh, bearing the very obvious marks of lust and pain. Just as Degas monumentalized the dancers in the late ballet pictures, by arranging the figures in a row and concentrating entirely on the arm movements, so too he began to focus on a single detail of the figure at her toilette: thus he produced a series of backs, seen in close-up and framed by exotic patterns of color that merely hint at the boudoir setting—the physical detail of the room is dissolved into bands of color, although a residual sense of space is preserved. In *The Breakfast after the Bath* (illus. opposite), this shift toward abstraction is unusually combined with a narrative element. The bath towel lies on the carpet like a semi-animate being that is being maltreated by the large trampling feet of the young woman, who is caught in a most indecorous pose, extending her bottom over the edge of the bath as she furiously dries her hair. But why should she make any effort to behave otherwise? The maid entering the room to bring the woman her breakfast chocolate is, after all, a familiar or subservient figure whose opinion can safely be ignored.

The two women, whose natural gestures are recorded precisely, are placed in a decorative setting that includes a variety of materials—ranging from porcelain and metal to flesh and hair—and textures that are smooth, grainy, or rippled. There are patterns of dots and flowers, and the colors include lemon yellow, ocher, bronze, blue, violet, and purple, and various shades of green, both warm and cool. The towels, the hair, the arms and body of the naked figure, all form a series of generously proportioned arabesques.

These shapes gradually expand to fill the entire picture. Motifs such as the act of toweling the neck or the armpits supply a point of departure for tireless explorations of gesture, featuring *ports de*

The Breakfast after the Bath,
ca. 1895

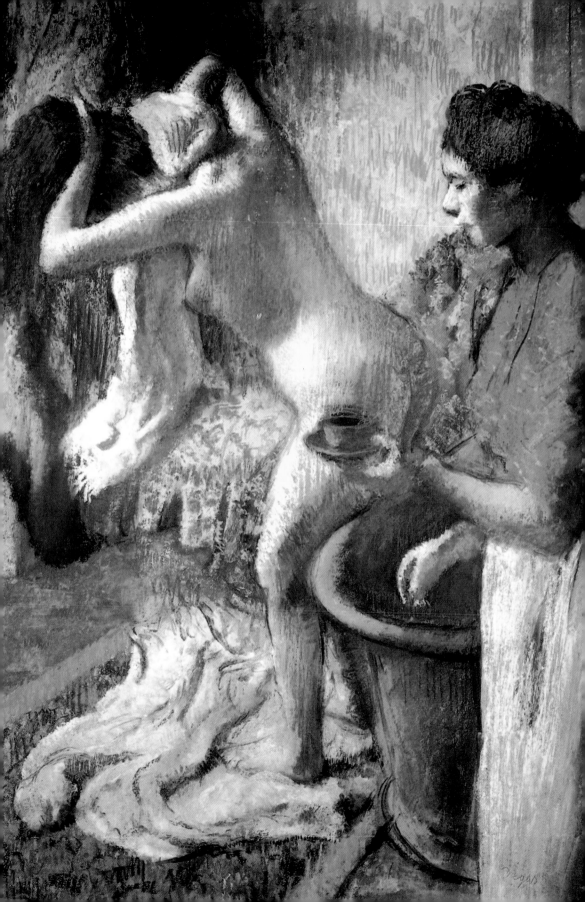

bras like those found in the ballet paintings, and elaborate maneuvers with the towel that recall the dancing movements of a *torero*. Where the seated upper body is enveloped and caressed by thick towels, it is made to twist and tilt in every conceivable manner; the muscles are stretched and contorted, and the position of the hips is visibly strained. And, moreover, every shift of viewing angle produces new combinations of lines. The art of anatomical analysis has rarely been taken to such extremes of precision.

But this is also an art of texture. The lines and bands of color, the striations, the calligraphic flourishes, the dots and sprinklings and smearings, are applied in a gestural manner, to create a surface whose roughness and porosity displays a palpable sensuousness. The visible sweep of the artist's hand enables the beholder to study the process by which the drawing has been created—this is one of the specifically "modern" aspects of Degas' oeuvre. In many instances, the formal structures are opposed by the hatching, which almost invariably runs diagonally over the surface of the body and breaks up its rounded contours, continuing across the edge even where the colors change. The light, conveyed by the patches and rubbings and filigree lines of white, explores the thighs, the breasts, the shoulder blades, the armpits, and the crook of the arm, transforming bath towels into luminescent cascades of material and causing the surface of the bathwater to glitter, giving body to the curtains and rhythm to the coloring.

Above all, this is an art of explosive color. The large expanses of flesh and drapery give the colors more scope to expand, and allow them to glow with a greater intensity than in the ballet paintings. The nakedness of the figures makes them more dazzling to the viewer. The gestures may be anatomically accurate, but the colors take on an arbitrary quality that bears little relation to reality; they are filled with the glitter and brashness of artificial harmonies. Certainly, the fiery tones—including orange, crimson, coral pink, violet, and purple—of the billowing curtains are partly subdued by the pale blues and chalky or creamy whites of the towels, and by the violet-tinged gray and metallic green of the bathtub. But the skin may be drawn in exactly the same shade of apricot as the curtain, or parts of its surface may reflect the green pattern of the cushion; the dark-brown hair may be echoed by a ragged strip of

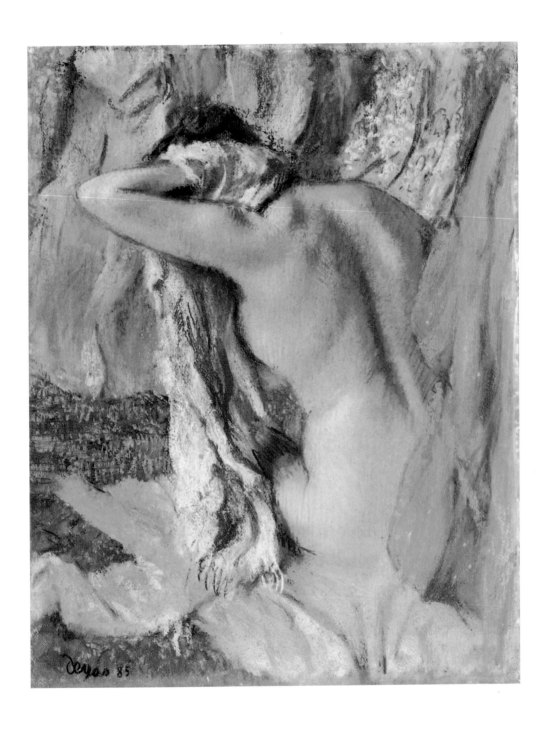

After the Bath, 1890–93 (dated 1885 by a later hand)

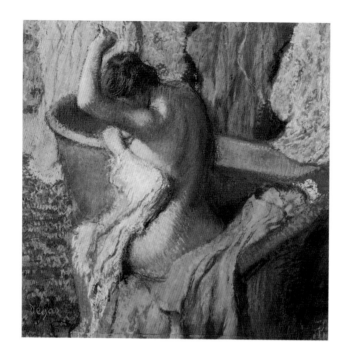

*Seated Bather Drying
Herself*, ca. 1895

*After
the Bath:
Woman Drying
Herself*,
1890–95

facing page
*After
the Bath:
Woman Drying
Herself*,
1895–1905

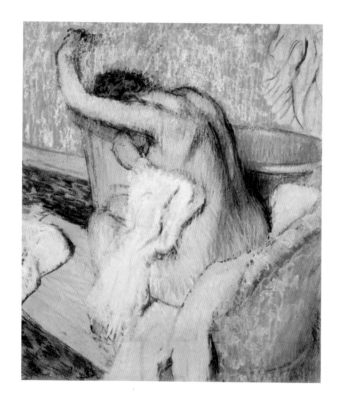

108

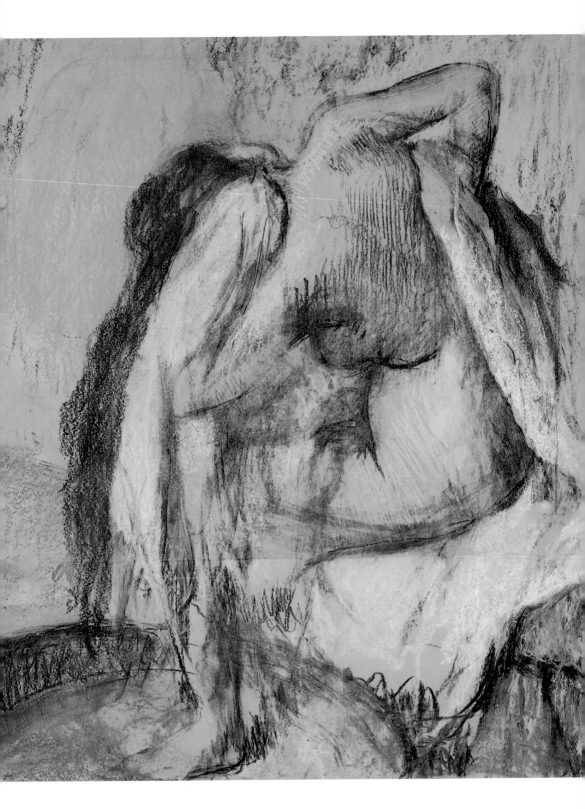

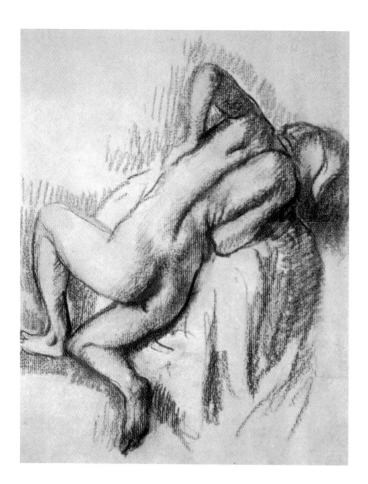

material, or the woman's thigh may pick up the quicksilver glint of the light falling on the towel. In one case the skin is ash-gray and the body frighteningly distorted, thereby anticipating the art of Francis Bacon, which takes the maltreatment of human flesh to its ultimate extreme, and was also much influenced by Muybridge's sequential photographs. By this point, Degas had begun to worry his friends with continual and somewhat exaggerated accounts— combining hypochondria, self-mockery, and genuine despair in equal measure—of his steadily failing eyesight. "These days, I can see only with my fingers," he complained. But the wild outbursts of chromatic fury in his late pictures have nothing to do with his blindness: the bather images from around 1900, which repeat the

familiar Michelangelo pose yet again, and with an even greater boldness and verve, are drawn with supreme confidence, and their semi-abstract coloring has an extraordinary, jewel-like beauty (illus. pp. 79, 109).

A new and somewhat bizarre motif is found in these late works: the image of a slender female figure draped over the high, thickly upholstered back of a chaise-longue and contorting her limbs as she wrestles with the bath towel. Degas explored this idea in a variety of media, including charcoal (illus. opposite) and pas-

Study of a Nude, 1896

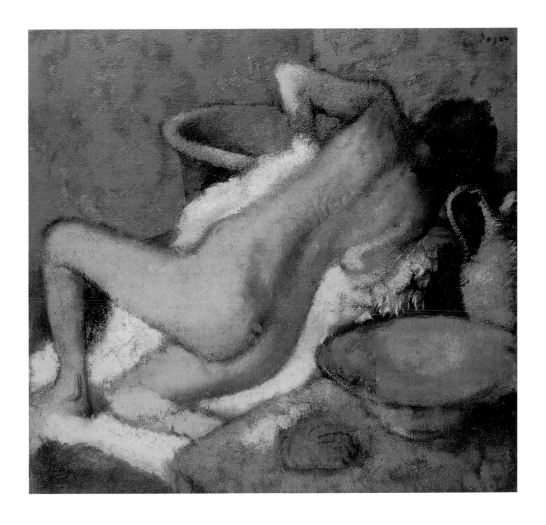

tel, and possibly photography—a photograph of a woman with her body arranged in this way has been ascribed to the artist himself (illus. below), who also took the motif as the occasion for some exercises in oil painting, which he had abandoned almost entirely (illus. p. 111). The convulsive appearance of the model's body has given rise to a number of widely differing interpretations.[31] Is the young woman writhing in physical pain or is she wracked by spiritual anguish? The brooding, almost medieval tone of the red version of the picture would tend to confirm the latter reading, suggesting that the figure is undergoing some form of mental torment—pursuing this line of thinking further, one notices the form of the bathtub by the bed, which resembles a sarcophagus. An alternative view is that the figure, painted with exceptional delicacy, is surrendering to the self-administered pleasures of the flesh. This, too, is a persuasive interpretation, which can be accepted even without the corroboration supplied by the more colorful versions. But why should the two readings of the picture be regarded as mutually exclusive? For Degas, pain and pleasure were clearly two sides of the same coin.

"The human animal appears in a harsh glow of nakedness."[32] Thus the German critic Julius Meier-Graefe described the impact of Degas' art in his monograph of 1920, infused with an Expressionist pathos that was fully in keeping with its subject. Certainly there can be no denying the element of pathos in Degas' late "boudoir" pictures, despite the emphasis on everyday actions and the unabashed naturalness of the figures. The gestures assume a ritual, monumental character, and the forms of the body are conceived in terms of sculpture; the dramas and rhythms of decorative art, with its stylized torsos and draperies, are raised to the level of grand metaphor, transforming scenes of warmth and physical well-being into images of pain, lust, loneliness, and frenzied torment. Traces of the classical, directly inscribed in the modern, make the spell of these images all the more powerful. Here, Degas does indeed achieve his stated purpose as an artist: "To bewitch truth and give it the appearance of madness."

After the Bath, 1896; photograph

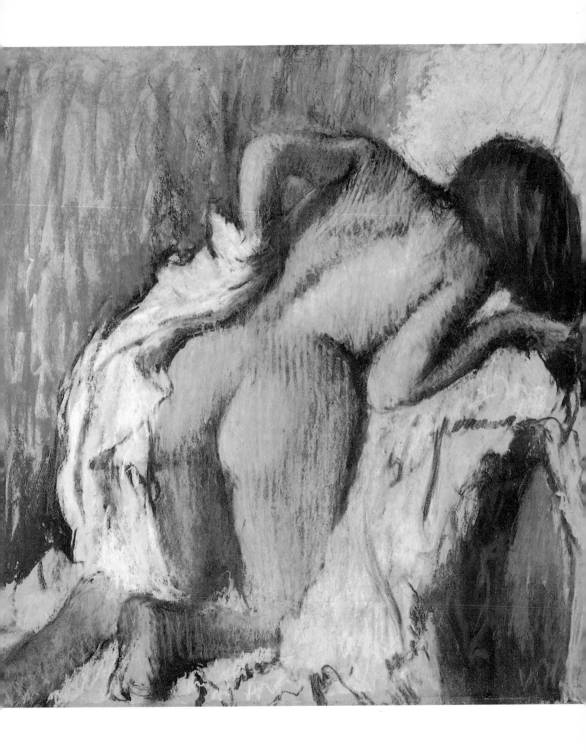

Woman Drying Herself, ca. 1894

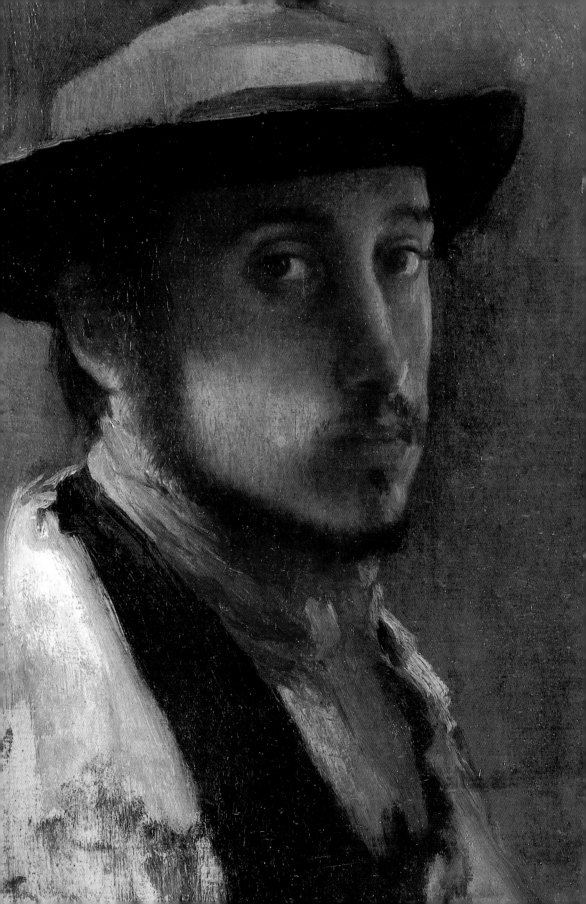

Self-Portrait in a Soft Hat, 1857

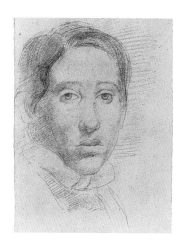

Self-Portrait,
1854

1834

Hilaire-Germain-Edgar de Gas (the surname is later
changed to Degas) is born in Paris on July 19. His father,
Pierre-Auguste-Hyacinthe de Gas, is of mixed French
and Italian descent; a lover of music and art, he runs the
Paris branch of the family banking business, based in
Naples. Degas' mother, Célestine Musson, is a member
of a prosperous Creole family from New Orleans. She
dies in 1847 at the age of thirty-two, leaving three sons
and two daughters.

1835–55

After attending the prestigious Lycée Louis-le-Grand,
Degas begins to study law, but soon switches to art, with
his father's consent, and enters the studio of the painter
Félix Barrias, before going to work under Louis Lamothe,
a disciple of Ingres, at the Ecole des Beaux-Arts. He is
unable to study with Ingres himself—who, together with
Delacroix, is one of his great idols—but has several
opportunities to meet the master and talk to him about
artistic matters.

1852–70

Second Empire

1856–59

Extended periods of study in Italy, especially in Rome,
Naples, and Florence.

ca. 1860

Paints in Paris (*The Bellelli Family*) and Normandy (history
paintings and early racehorse pictures), staying at the
country home of the collector Edouard Valpinçon.

1860–69

Makes the acquaintance of Edouard Manet and the
proto-Impressionist circle at the Café Guerbois, whose
members include Camille Pissarro, Berthe Morisot, and
Jean-François Raffaëlli. Concentrates on portraiture and
discovers Japanese prints, which have a major impact on
his ideas about composition. *Scene of War in the Middle Ages*
exhibited at the Salon in 1865.

1868

Conceives an interest in theater; creates first pictures of
musicians, orchestras, stage scenes, and ballet rehearsals.

1870–72

Enlists in the national guard at the beginning of the
Franco-Prussian War and serves in the artillery. Stays in
Normandy during the Paris Commune. His sight begins
to trouble him.

1871

Proclamation of the Third Republic.

Degas, ca. 1855–60

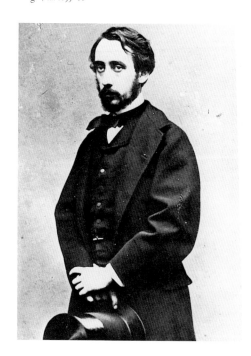

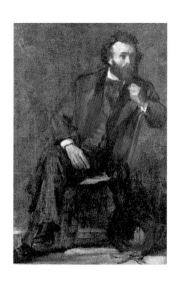

*Portrait of
Gustave Moreau,
ca. 1868*

1872–73

Travels with his brother René to New Orleans, where
they have relatives in the cotton trade (*The Cotton Exchange
at New Orleans*).

1874

Death of his father in Naples, followed by the collapse of
the bank's Paris branch. As the eldest surviving member
of the family, Edgar Degas assumes full responsibility for
the debts. From now on, his livelihood depends on the
sale of his pictures.
Creates paintings and drawings of everyday subjects,
including laundresses, *modistes* and *café-concert* singers.
First Impressionist exhibition in Paris, held under the
title "Première Exposition de la Société anonyme des
artistes peintres, sculpteurs, graveurs," featuring ten works
by Degas, who plays a leading role in organizing the
event. Although he takes a critical view of Impressionism
—especially of its emphasis on *plein air* painting and its
abandonment of line—Degas nevertheless continues to
participate in the group's exhibitions.

1875–78

Further extended stay in Italy.
Produces major works *Place de la Concorde*, also known as
Vicomte Lepic and His Daughters (1875), and *In a Café* (*The
Absinthe Drinker*) (1876).
First museum purchase of a work by Degas, *The Cotton
Exchange at New Orleans*, which is acquired by the Musée
des Beaux-Arts in Pau.

1879

Fourth Impressionist exhibition. At Degas' suggestion,
the group adopts the name "Indépendants."
Degas collaborates with the printmaker Félix Bracque-
mond and the painters Camille Pissarro and Mary
Cassatt on a number of etchings to be included in a
publication titled *Le Jour et la Nuit*.

1880–90

Composes sonnets to dancers, singers, and horses.
An obsessive collector, Degas purchases large numbers of
Old Master paintings and pictures by contemporary
artists, including Ingres, Delacroix, Cézanne, Van Gogh,
Manet, and Gauguin. By the time of his death, his collec-
tion totals around 5,000 works.

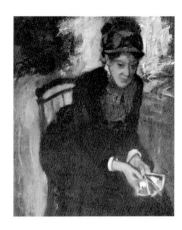

*Portrait of
Mary Cassatt,
ca. 1884*

His circle of acquaintances during this period includes
the writers Edmond de Goncourt, Emile Zola, Oscar
Wilde, Stéphane Mallarmé, Paul Valéry, and Offenbach's
librettist Ludovic Halévy, whose son, Daniel, wrote about
him; the salon hostesses Meredith Howland and Gene-
viève Straus; and the painters Walter Sickert, Gustave
Moreau, James Whistler, Odilon Redon, and Jean-
François Millet.
The writer and critic George Moore gave the following
description of the studio, at 21, rue Pigalle in Montmartre,
that Degas occupied for most of the 1880s: "Some four,
or perhaps five, years after, one morning in May, a friend
tried the door of Degas' studio. It was always strictly
fastened, and when shaken vigorously a voice calls from
some loophole; if the visitor be an intimate friend, a
string is pulled and he is allowed to stumble his way up
the cork-screw staircase into the studio. There are there
neither Turkey carpets nor Japanese screens, nor indeed

any of those signs whereby we know the dwelling of the modern artist. Only at the further end, where the artist works, is there daylight. In perennial gloom and dust the vast canvases of his youth are piled up in formidable barricades. Great wheels belonging to lithographic presses —lithography was for a time one of Degas' avocations— suggest a printing-office. There is much decaying sculpture—dancing girls modelled in red clay, some dressed in muslin skirts, strange dolls—dolls if you will, but dolls modelled by a man of genius."[33]

Degas, Dieppe, 1885

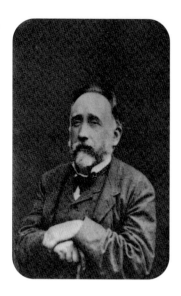

1881

The sculpture *Little Dancer of Fourteen Years* sparks a major controversy when it goes on show in the sixth Impressionist exhibition. Paul Durand-Ruel begins to act as Degas' dealer.

1884

The female nude, depicted in a bedroom or brothel setting, takes on a central importance in Degas' oeuvre. His earliest experiments with the genre, dating from 1877, are

Degas, Dieppe, 1885

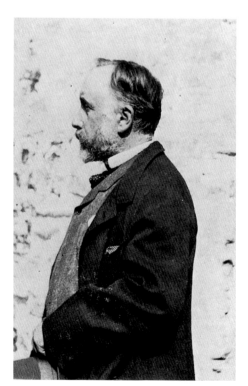

in the medium of monotype printing, but from the early 1880s on, he increasingly concentrates on pastel drawing. A series of these pastels is shown at the eighth and final Impressionist exhibition, and attracts a great deal of attention.
Degas rewards Durand-Ruel for his success in promoting his work by appointing him as his sole representative. Takes part in the exhibition of Impressionist painting in New York.

1889

Travels to Spain and Morocco, accompanied by the Italian portraitist Giovanni Boldini.

1890

Moves into a studio and apartment at 37, rue Victor Massé in Montmartre.
Tours Burgundy with the sculptor Paul-Albert Bartholomé. Sketches landscapes and immediately makes monotypes of them, using the studio in the summer quarters of his friend Georges Jeanniot.

1893

First one-man exhibition, at the Galerie Durand-Ruel, showing only the landscape prints made in Burgundy.

1895–1900

Abandons oils almost completely in favor of pastel, concentrating on dancers and female nudes.
The retrial of Alfred Dreyfus, a French officer of Jewish descent who had been convicted of treason in 1894 and sent to Devil's Island, causes bitter controversy. Public opinion is split between Dreyfus' liberal supporters and his nationalist opponents, including Degas, whose violent anti-Semitism puts an end to his long-standing friendship with Ludovic Halévy, and alienates a number of his other acquaintances.

After 1900

By now almost blind, Degas draws large-format pastels in heavy impasto. He also makes a series of sculptures, chiefly for his own amusement.

above
Degas (left)
with Geneviève Straus,
Albert Cavé,
and Léon Ganderax,
Paris, ca. 1886

Parody of Ingres'
The Apotheosis of Homer;
photograph set up by Degas (center)
at Bas-Fort-Blanc
near Dieppe in 1885

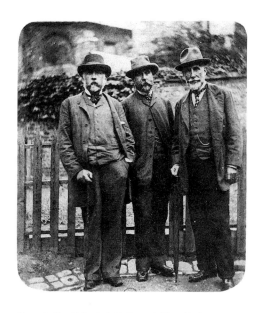

Degas (left) with Ludovic Halévy and Albert Cavé,
Dieppe, 1885

Degas, ca. 1895–1900;
photograph attributed to the
artist's brother, René de Gas

The rue Victor Massé, Paris,
ca. 1900, with Degas' studio and
apartment at left

Degas on the boulevard de Clichy, Paris, ca. 1912–14

Degas in the garden of Paul-Albert Bartholomé's house at
Auteuil, ca. 1908

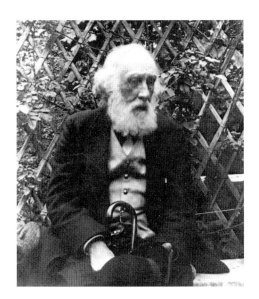

1912

Second one-man exhibition, at the Fogg Art Museum in
Cambridge, Mass. Evicted from the rue Victor Massé, as
the building is scheduled for demolition. Rents a new
apartment and studio at 6, boulevard de Clichy.

1917

Degas dies on September 27 and is buried in the family
plot in the Cimetière de Montmartre. His tombstone
bears the legend "Il aimait beaucoup le dessin" (He loved
drawing very much).

1996

A large boudoir picture is sold at Christie's in New York
for $4.5 million, while a pastel of a dancer fetches $1.7
million at Sotheby's, and a bronze cast of the *Little
Dancer of Fourteen Years* changes hands at no less than
$10.8 million.

List of Illustrations

Illustrations are listed in the order in which they appear in this volume

The Tub, ca. 1880
Monotype, dimensions unknown
Location unknown
page 86

Woman Bathing in a Shallow Tub, 1885
Pastel on paper, 32 x 22 in. (81.3 x 55.9 cm)
New York, The Metropolitan Museum of
Art; H. O. Havemeyer Collection
page 87

The Tub, 1876–77
Monotype, 16 ¹/₂ x 21 ¹/₄ in. (42 x 54.1 cm)
Universités de Paris, Bibliothèque d'Art et
d'Archéologie
page 88

Nude Woman Combing Her Hair, 1879–83
Monotype, 12 ³/₈ x 11 in. (31.3 x 27.9 cm)
Paris, Musée du Louvre, Cabinet des Dessins
page 89

Woman Leaving Her Bath, 1879–83
Monotype, 11 x 14 ³/₄ in. (28 x 37.5 cm)
Private collection
page 90

Woman Standing in Her Bath, 1879–83
Monotype, 15 x 10 ⁵/₈ in. (38 x 27 cm)
Paris, Musée du Louvre, Cabinet des Dessins
page 91

Nude Woman Scratching Herself, 1879–83
Monotype, 10 ⁷/₈ x 14 ⁷/₈ in. (27.6 x 37.8 cm)
London, British Museum
page 92

Torso of a Woman, 1889–90
Monotype, 19 ¹/₄ x 15 ¹/₂ in. (50 x 39.3 cm)
Paris, Bibliothèque Nationale,
Cabinet des Estampes
page 93

Woman Bathing in a Shallow Tub, 1886
Pastel on paper,
23 ⁷/₈ x 32 ⁵/₈ in. (60 x 83 cm)
Paris, Musée d'Orsay
page 94

Woman Bathing in a Shallow Tub, 1885–86
Pastel on paper,
27 ¹/₂ x 27 ¹/₂ in. (70 x 70 cm)
Farmington, Conn., Hill-Stead Museum
page 95

The Morning Bath (The Baker's Wife), 1885–86
Pastel on paper,
26 ³/₈ x 20 ¹/₂ in. (67 x 52.1 cm)
The Henry and Rose Pearlman Foundation
page 96

After the Bath, 1883–84
Pastel and wash on paper,
20 ¹/₂ x 12 ⁵/₈ in. (52 x 32 cm)
Private collection
page 97

Nude Woman Having Her Hair Combed,
1886–88
Pastel on paper,
29 ¹/₈ x 23 ⁷/₈ in. (74 x 60.6 cm)
New York, The Metropolitan Museum of
Art; H.O. Havemeyer Collection
page 99

Nude Woman Drying Herself, 1885
Pastel on paper,
31 ¹/₂ x 20 ¹/₈ in. (80.1 x 51.2 cm)
Washington, D.C., National Gallery of
Art; Gift of the W. Averell Harriman
Foundation in Memory of Marie N.
Harriman
page 100

Woman with a Towel, 1898
Pastel on paper,
37 ¹/₂ x 29 ¹/₂ in. (95.4 x 75.5 cm)
New York, The Metropolitan Museum of
Art, H. O. Havemeyer Collection
page 100

Nude Woman Combing Her Hair, 1886–88
Pastel on paper, 31 x 26 in. (78.7 x 66 cm)
Collection of Mr. and Mrs. A. Alfred
Taubman
page 101

The Tub, 1888–89
Wax, lead, plaster, cloth, and wood,
9 ¹/₂ x 16 ¹/₂ in. (24 x 42 cm)
Washington, D.C., National Gallery of
Art; Collection of Mr. and Mrs. Paul
Mellon
page 102

The Masseuse, ca. 1895
Bronze, h. 17 in. (43.2 cm)
Washington, D.C., National Gallery of
Art; Collection of Mr. and Mrs. Paul
Mellon
page 103

Woman Leaving Her Bath, 1895–1900
Bronze, h. 16 ⁵/₈ in. (42.1 cm)
Pasadena, The Norton Simon Museum
of Art
page 103

The Breakfast after the Bath, ca. 1895
(dated 1885 by a later hand)
Paste and brush on tracing paper,
47 ⁵/₈ x 36 ¹/₄ in. (121 x 92 cm)
Private collection
page 105

After the Bath, 1890–93
(dated 1885 by a later hand)
Pastel on tracing paper,
26 x 20 ³/₄ in. (66 x 52.7 cm)
Pasadena, The Norton Simon Museum
of Art
page 107

Seated Bather Drying Herself, ca. 1895
Pastel on paper,
20 ¹/₂ x 20 ¹/₂ in. (52 x 52 cm)
Private collection
page 108

After the Bath: Woman Drying Herself,
1890–95
Pastel on tracing paper,
40 ⁷/₈ x 38 ³/₄ in. (103.8 x 98.4 cm)
London, National Gallery
page 108

After the Bath: Woman Drying Herself,
1895–1905
Pastel and charcoal on tracing paper,
47 ⁵/₈ x 39 ³/₄ in. (121 x 101 cm)
Stuttgart, Staatsgalerie,
Graphische Sammlung
page 109

Female Nude, ca. 1889
Charcoal and pastel on paper,
12 ¹/₄ x 9 ¹/₂ in. (31.5 x 24 cm)
Private collection
page 110

Study of a Nude, 1896
Oil on canvas, 30 ¹/₄ x 32 ⁵/₈ in. (77 x 83 cm)
Private collection
page 111

After the Bath, 1896
Bromide print, 6 ¹/₄ x 4 ⁷/₈ in. (16.5 x 12 cm)
Malibu, The J. Paul Getty Museum
page 112

Woman Drying Herself, ca. 1894
Pastel on paper,
25 ⁵/₈ x 24 ³/₄ in. (65 x 63 cm)
Edinburgh, National Gallery of Scotland
page 113

Self-Portrait in a Soft Hat, 1857
Oil on paper, 10 $^1/_4$ x 7 $^1/_2$ in. (26 x 19 cm)
Williamstown, Mass., Sterling and
Francine Clark Art Institute
page 114

Self-Portrait, 1854
Pencil on paper, 13 x 9 $^3/_8$ in. (33 x 23.8 cm)
Zurich, Walter Feilchenfeldt
page 116

Degas, ca. 1860; photograph
Paris, Bibliothèque Nationale
page 116

Portrait of Gustave Moreau, ca. 1868
Oil on canvas, 15 $^3/_4$ x 10 $^5/_8$ in. (40 x 27 cm)
Paris, Musée Gustave Moreau
page 117

Portrait of Mary Cassatt, ca. 1884
Oil on canvas,
28 $^1/_8$ x 23 $^1/_8$ in. (71.5 x 58.7 cm)
Washington, D.C., Smithsonian
Institution, National Portrait Gallery
page 117

Degas, Dieppe, 1885; photograph
Paris, Bibliothèque Nationale
page 118

Degas, Dieppe, 1885; photograph by Barnes
Paris, Bibliothèque Nationale
page 118

Degas, Geneviève Straus, Albert Cavé, and
Léon Ganderax, Paris, ca. 1886; photograph
Paris, Bibliothèque Nationale
page 119

Parody of Ingres' *The Apotheosis of Homer*;
photograph set up by Degas, and taken by
Barnes, at Bas-Fort-Blanc near Dieppe, 1885
Paris, Bibliothèque Nationale
page 119

Degas, Ludovic Halévy, and Albert Cavé,
Dieppe, 1885; photograph by Barnes
Paris, Bibliothèque Nationale
page 120

Degas, ca. 1895–1900;
photograph attributed to René de Gas
page 120

The rue Victor Massé, Paris, ca. 1900,
with Degas' studio and apartment at left;
postcard
Paris, Bibliothèque Nationale
page 120

Degas on the boulevard de Clichy, ca.
1912–14; photograph by Sacha Guitry
Paris, Bibliothèque Nationale
page 121

Degas in the garden of Paul-Albert
Bartholomé's house at Auteuil, ca. 1908;
photograph by Paul-Albert Bartholomé
Paris, Bibliothèque Nationale
page 121

1 Quotations from exhibition reviews by Jules Claretie (*La Vie à Paris*, April 23, 1881), Paul Mantz (*Le Temps*, April 23, 1881), and Henry Trianon (*Le Constitutionnel*, April 24, 1881).

2 See, for example, Anthea Callen, *The Spectacular Body: Science, Method and Meaning in the Work of Degas* (New Haven and London, 1995), especially chapters 3 and 4.

3 Willibald Sauerländer, "Physiognomie und Moderne: Anmerkungen zur Ausstellung der Porträts von Edgar Degas in Tübingen," *Süddeutsche Zeitung*, March 18-19, 1995.

4 Paul Valéry, *Degas danse dessin* (Paris, 1934); quoted in Robert Gordon and Andrew Forge, *Degas* (New York, 1988), p. 34.

5 Letter to Paul-Albert Bartholomé, January 17, 1886, in *Lettres de Degas*, ed. Marcel Guérin (Paris, 1945), p. 119.

6 Quoted in Georges Jeanniot, "Souvenirs sur Degas," *La Revue Universelle*, vol. 55 (October 15, 1933), p. 158.

7 Quoted in *Degas*, exh. cat. (Ottawa and New York, 1988), p. 274.

8 Rainer Maria Rilke, "Der Salon der Drei," in *Sämtliche Werke*, vol. 5 (Frankfurt am Main, 1965), p. 453.

9 Letter to Evariste Bernardi de Valernes, October 26, 1890, in *Lettres de Degas* (note 5), p. 178.

10 Lillian Browse, *Degas Dancers* (London, 1949), p. 68, summarizing a description of the "rats" by Nester Roqueplan, director of the Paris Opéra, 1849-54.

11 See Theodore Reff, *Degas: The Artist's Mind* (New York, 1976), pp. 216–21.

12 Quoted in Ivor Guest, *The Ballet of the Second Empire*, 2 vols. (London, 1953), vol. 1, p. 12.

13 See Reff (note 11), pp. 292 and 338, n. 56.

14 Jean Adhémar and Françoise Cachin, *Degas: The Complete Etchings, Lithographs and Monotypes* (London and New York, 1974), p. 16.

15 Degas, Notebook 30 (Carnet 9), p. 65, in Theodore Reff (ed.), *The Notebooks of Edgar Degas*, vol. 1 (Oxford, 1976), p. 134.

16 Quoted in George T. M. Shackelford, *Degas: The Dancers*, exh. cat. (Washington, D.C., 1984), pp. 105–06.

17 Ibid., p. 106.

18 Quoted in Henri Hertz, *Degas* (Paris, 1920), p. 55.

19 Gordon and Forge (note 4), p. 218.

20 Letter to Paul-Albert Bartholomé, January 17, 1886, in *Lettres de Degas* (note 5), p. 188.

21 George Moore, *Confessions of a Young Man* (1888) (Montreal, 1972), p. 318.

22 Quoted in George Moore, "Memories of Degas," *Burlington Magazine*, vol. 32, no. 179 (February 1918), p. 64.

23 Werner Hofmann, *Das Irdische Paradies* (Munich, 1964), p. 38.

24 Quoted in Moore (note 22), p. 64.

25 Ivan Nagel, *Johann Heinrich Dannecker: Ariadne auf dem Panther* (Frankfurt am Main, 1993), p. 43.

26 Eunice Lipton, *Looking into Degas: Uneasy Images of Woman and Modern Life* (Berkeley, Los Angeles, and London, 1986), p. 169.

27 Félix Fénéon, *Les Impressionnistes en 1886* (Paris, 1886), pp. 9–10.

28 Anthea Callen (note 2), p. 100.

29 Otto Pächt, *Rembrandt* (Munich, 1991), p. 93.

30 [George Moore], in *The Bat*, May 25, 1886, p. 185.

31 See *Degas* (note 7), pp. 548–49.

32 Julius Meier-Graefe, *Degas: Ein Beitrag zur Entwicklungsgeschichte der modernen Malerei* (Munich, 1920), p. 81.

33 George Moore, "Degas: The Painter of Modern Life," *The Magazine of Art*, vol. 13 (1890), p. 416.

Adhémar, Jean, and Françoise Cachin. *Degas: The Complete Etchings, Lithographs and Monotypes*. London and New York, 1974.

Adriani, Götz. *Degas: Pastels, Oil Sketches, Drawings*. New York, 1985.

Boggs, Jean Sutherland, and Anne Maheux. *Degas Pastels*. London, 1992.

Browse, Lillian. *Degas Dancers*. London, 1949.

Callen, Anthea. *The Spectacular Body: Science, Method and Meaning in the Work of Degas*. New Haven and London, 1995.

Degas. Exh. cat. Ottawa, National Gallery of Canada, and New York, Metropolitan Museum of Art, 1988–89. Ottawa and New York, 1988.

Gordon, Robert, and Andrew Forge. *Degas*. New York, 1988.

Guérin, Marcel, ed. *Lettres de Degas*. Paris, 1945.

Kendall, Richard, ed. *Degas by Himself*. London, 1987.

Kendall, Richard. *Degas beyond Impressionism*. Exh. cat. London, National Gallery. London, 1996.

Lipton, Eunice. *Looking into Degas: Uneasy Images of Woman and Modern Life*, Berkeley, Los Angeles, and London, 1986.

Meier-Graefe, Julius. *Degas: Ein Beitrag zur Entwicklungsgeschichte der modernen Malerei*. Munich, 1920.

Moore, George. "Degas: The Painter of Modern Life." *The Magazine of Art*, vol. 13 (1890), pp. 416–25.

Moore, George. "Memories of Degas." *Burlington Magazine*, vol. 32, no. 178 (January 1918), pp. 22–29, and no. 179 (February 1918), pp. 63–65.

Shackelford, George T. M. *Degas: The Dancers*. Exh. cat. Washington, D.C., National Gallery of Art. Washington, D.C., 1984.

Sutton, Denys. *Edgar Degas: Life and Work*. New York, 1986.

Thomson, Richard. *Degas: The Nudes*. London, 1988.

Valéry, Paul. *Degas danse dessin*. Paris, 1934. Trans. as "Degas Dance Drawing," in Paul Valéry, *Degas, Monet, Morisot* (Princeton, 1960).

Translated from the German by John Ormrod

Cover: *The Green Dancer*, ca. 1880 (detail); © Fundación Colección Thyssen-Bornemisza, Madrid (illus. p. 24)
Spine: *Dancers in the Wings*, 1878–80 (detail; illus. p. 51)
Frontispiece: *The Morning Bath*, ca. 1883 (recently dated 1892–95)
Pastel on paper, 26 1/4 x 17 3/4 in. (66.8 x 45 cm). The Art Institute of Chicago; Potter Palmer Collection

Library of Congress Cataloging-in-Publication Data

Schacherl, Lillian.
[Edgar Degas. English]
Edgar Degas : dancers and nudes / by Lillian Schacherl ;
translated from the German by John Ormrod.
p. cm.
Includes bibliographical references.
ISBN 3-7913-1738-5 (alk. paper : English ed.)
ISBN 3-7913-1791-1 (alk. paper : German ed.)
1. Degas, Edgar, 1834–1917—Criticism and interpretation.
2. Dancers in art. 3. Female nude in art. I. Title.
ND553.D3S3313 1997
759.4—dc21 97–3596
 CIP

Prestel books are available worldwide.
Please contact your nearest bookseller or write to
either of the following addresses for information
concerning your local distributor:
Prestel-Verlag, Mandlstrasse 26,
D-80802 Munich, Germany
Tel. (+49-89) 381 70 90, Fax (+49-89) 381 709 35
and 16 West 22nd Street,
New York, NY 10010, USA
Tel. (212) 627-8199, Fax (212) 627-9866

Designed by Albert Teschemacher, Munich, Germany
Typeset by Reinhard Amann, Aichstetten, Germany
Lithography by eurochrom 4, Villorba (TV), Italy
Printed and bound by Passavia Druckerei GmbH, Passau, Germany

Printed in Germany

ISBN 3-7913-1738-5 (English edition)
ISBN 3-7913-1791-1 (German edition)

Printed on acid-free paper